Home Is Where the Dog Is

Copyright © 2016 Marita Gale

All rights reserved.

ISBN-10: 1539393275
ISBN-13: 978-1539393276

Acknowledgements

I acknowledge and thank God for giving me the gift of art and writing to share with you.

I acknowledge and thank the following dogs and cat (who thinks she is a dog) for inspiring me to create this coloring book:

Home Is Where the Dog Is

Abby, Abby, Avi, Bella, Bentley, Bo, Boudreaux, Box Car Willy, Bruno, Charlie, Chauncey, Chi Chi, Cho Cho, Colten, Aspen, Desi, Forte, Gracie, Great Dane, Hari, Henry, Honey, Huckleberry, Kaylie, Ki, KiKi, Leo, Lilo, Lilly, Lita, Mama, Annie, Max, Wicket, Max, Mr. Bigz, Mia, Mica, Wolfgang, Molly, Popps, Pumpkin, Yoda, Zorro, Oreo, Radar, Rocky, Roo, and Rosie Sally, Sam, Sampson, Sassy, Scooter, Scruffy, Shiloh, Sienna, Skipper, Skipper, Snickers, Stuart, Witman

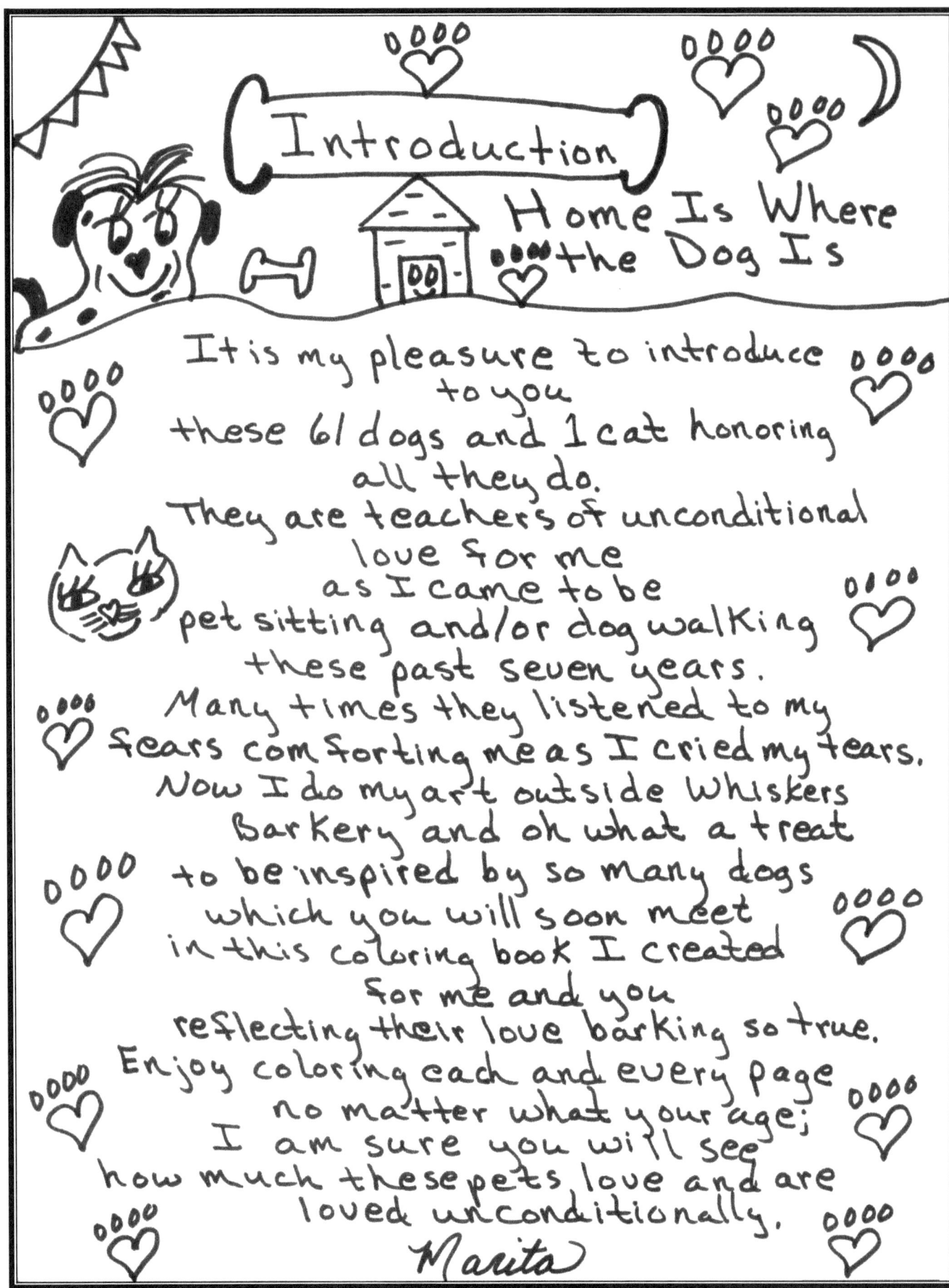

Introduction
Home Is Where the Dog Is

It is my pleasure to introduce to you
these 61 dogs and 1 cat honoring
all they do.
They are teachers of unconditional
love for me
as I came to be
pet sitting and/or dog walking
these past seven years.
Many times they listened to my
fears comforting me as I cried my tears.
Now I do my art outside Whiskers
Barkery and oh what a treat
to be inspired by so many dogs
which you will soon meet
in this coloring book I created
for me and you
reflecting their love barking so true.
Enjoy coloring each and every page
no matter what your age;
I am sure you will see
how much these pets love and are
loved unconditionally.

Marita

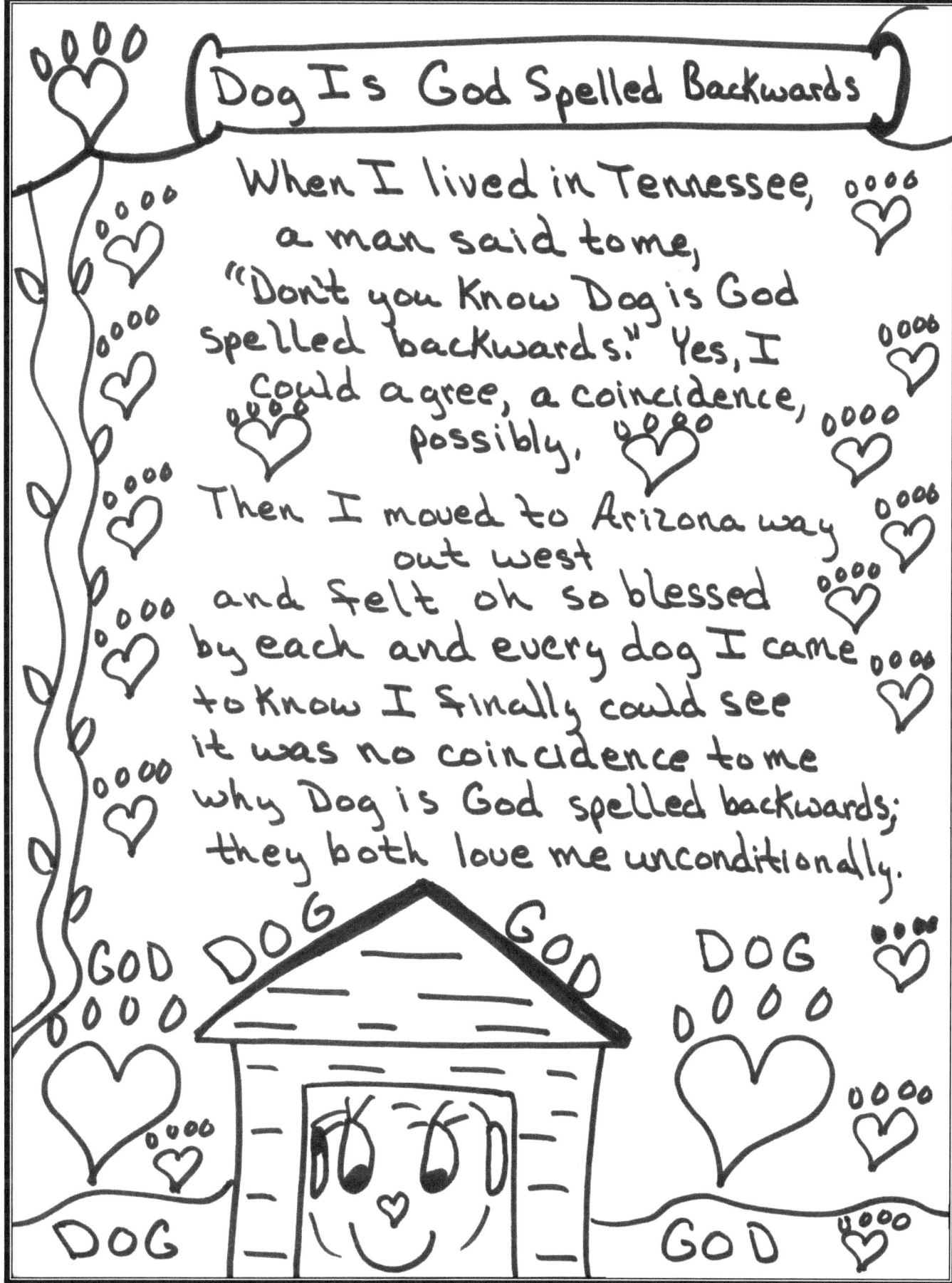

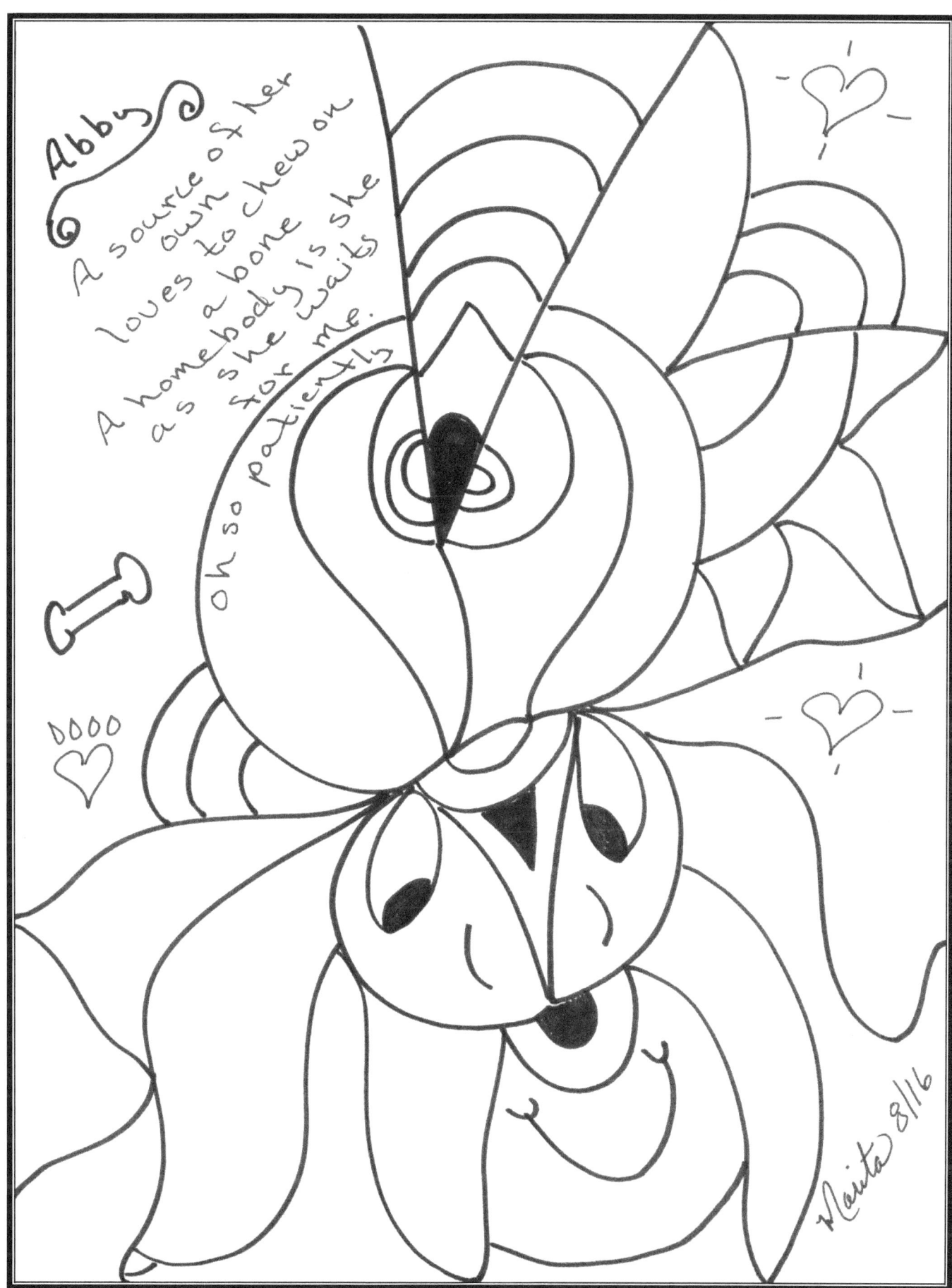

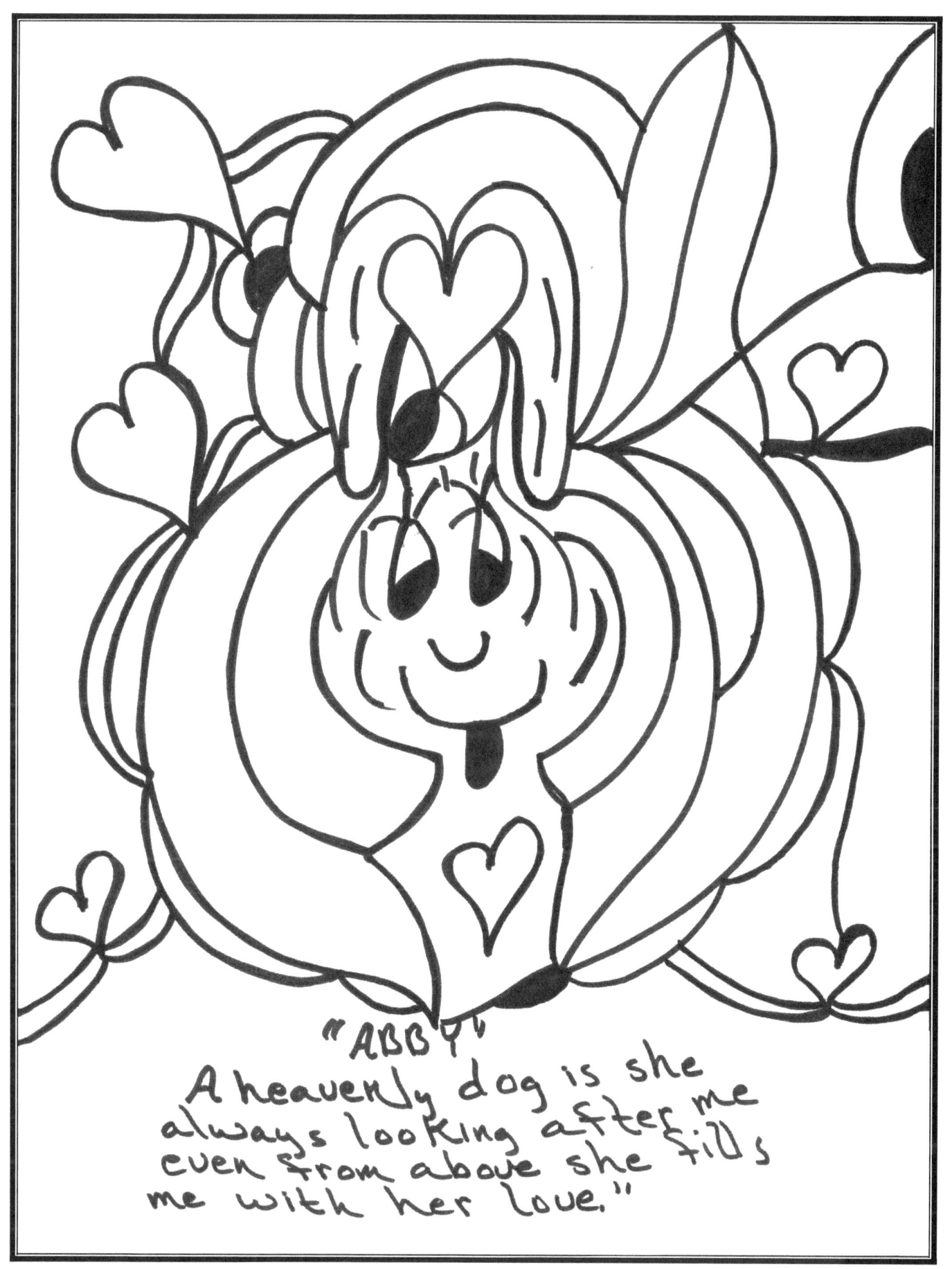

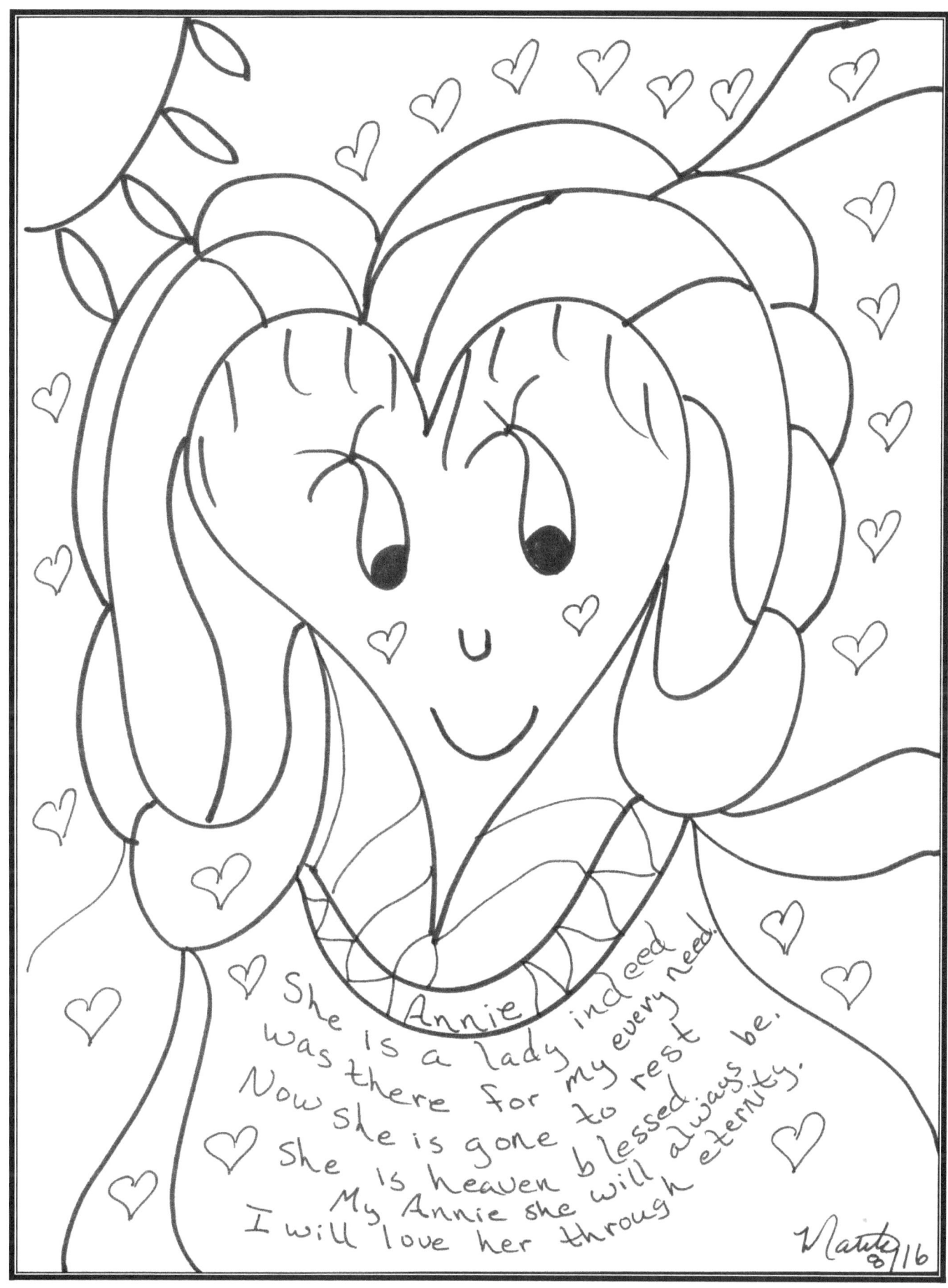

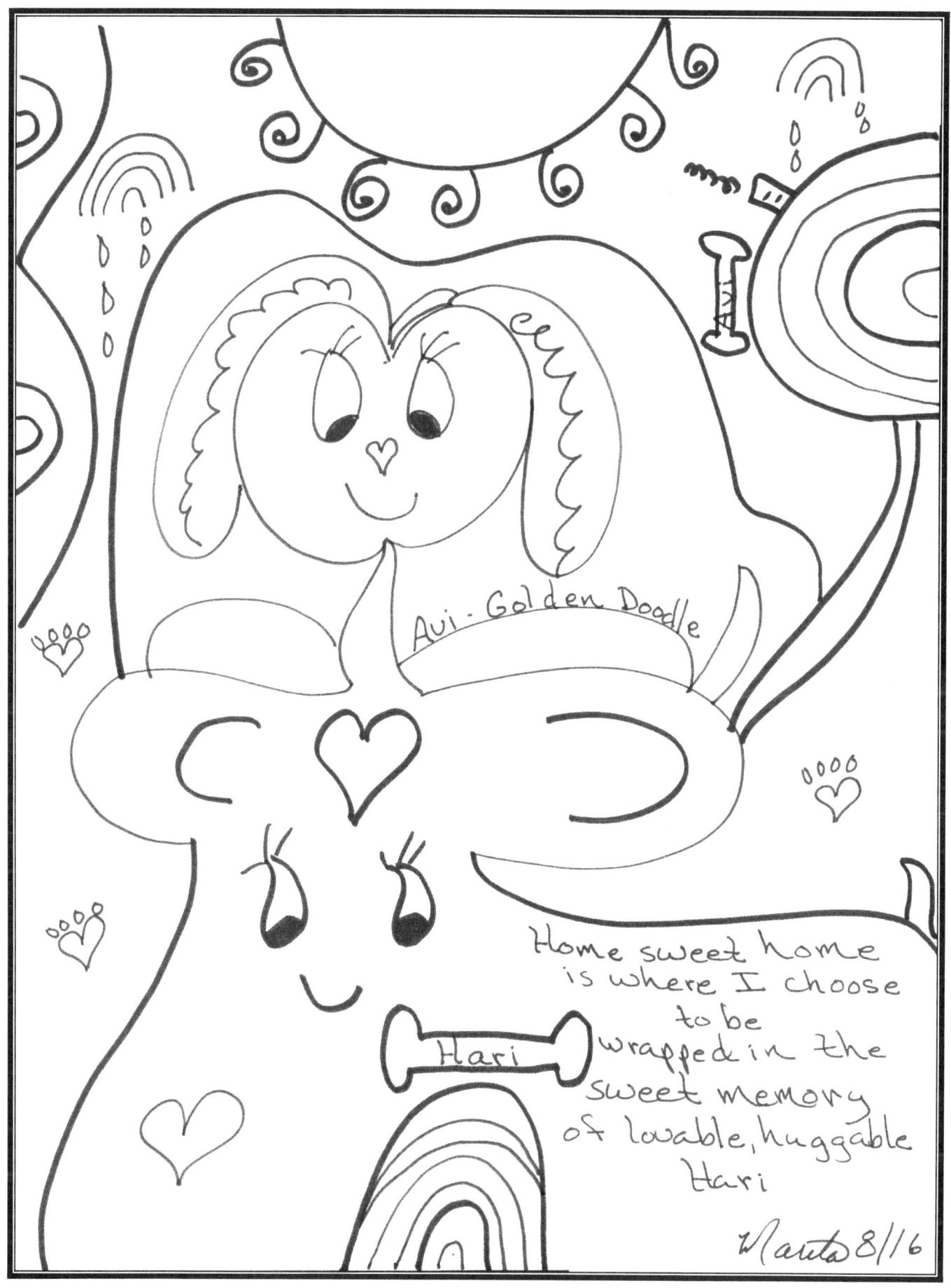

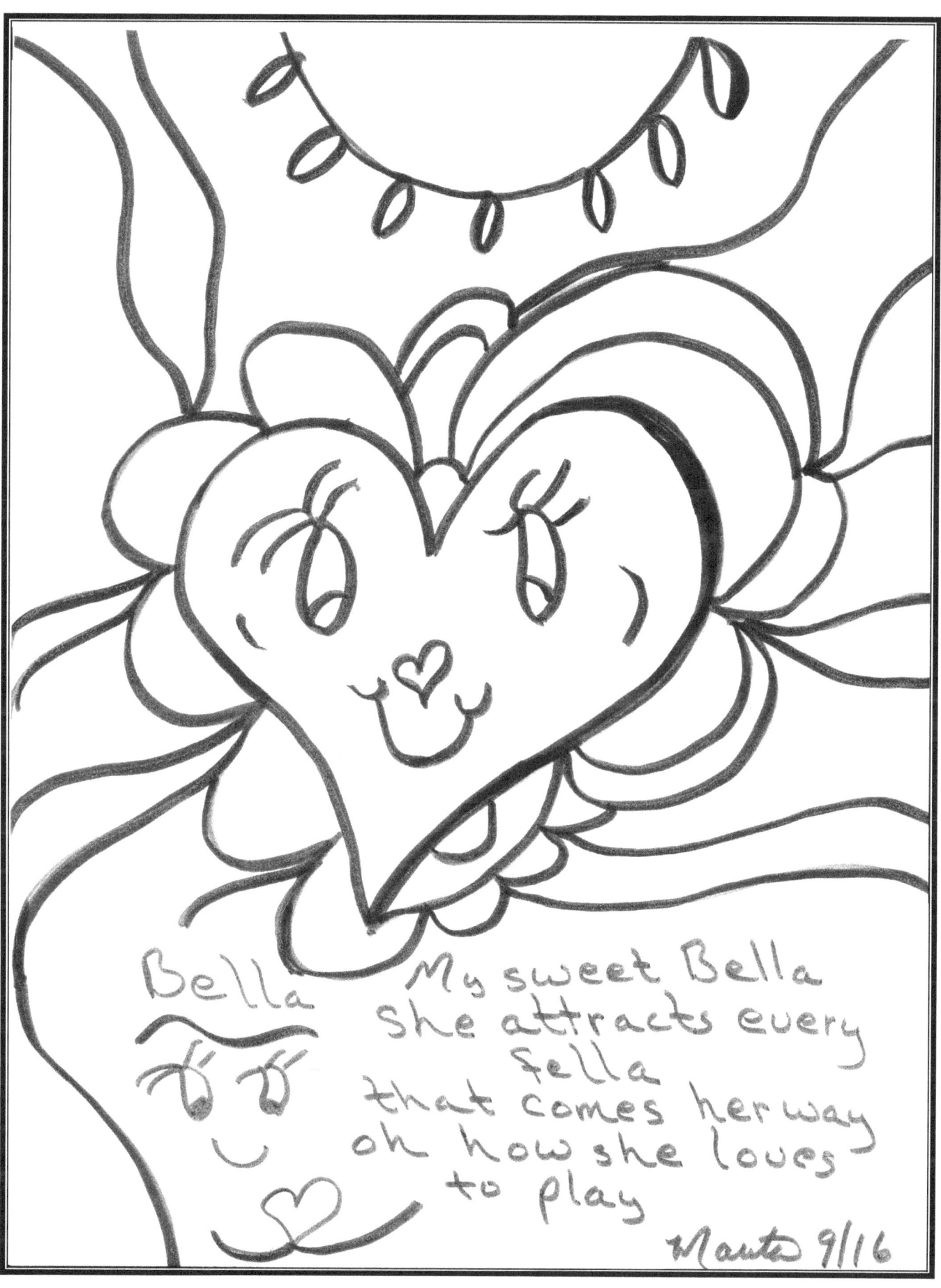

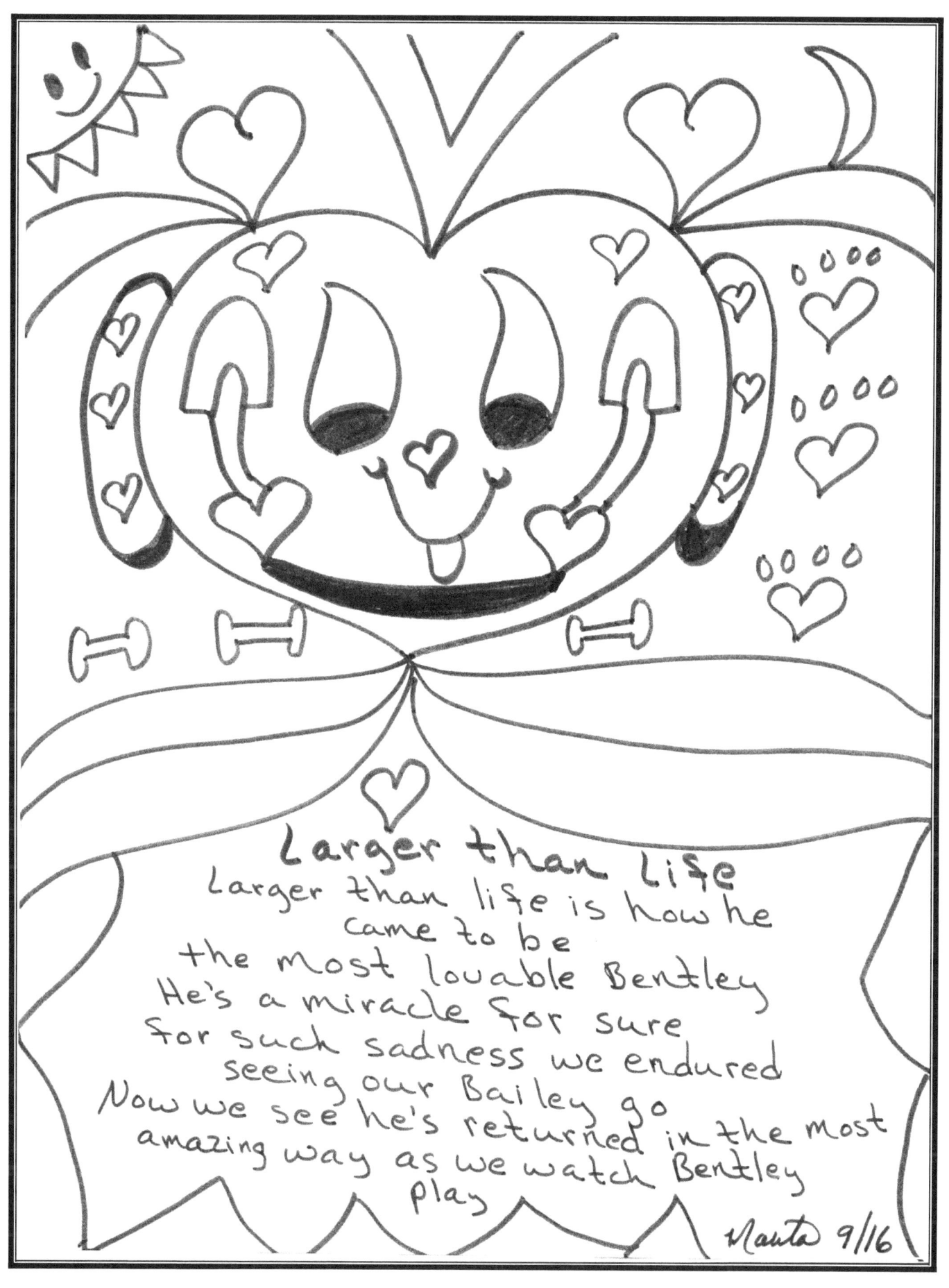

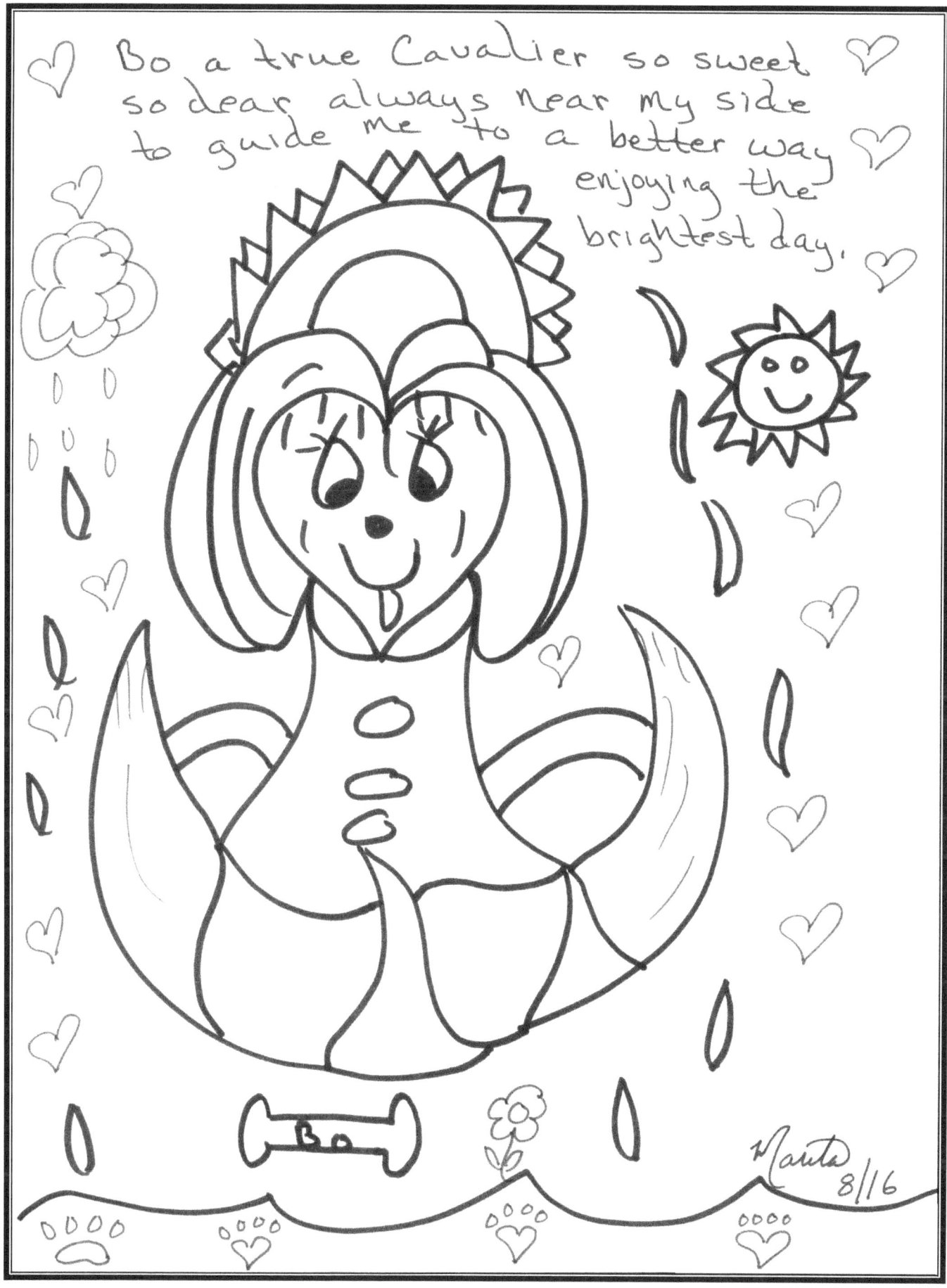

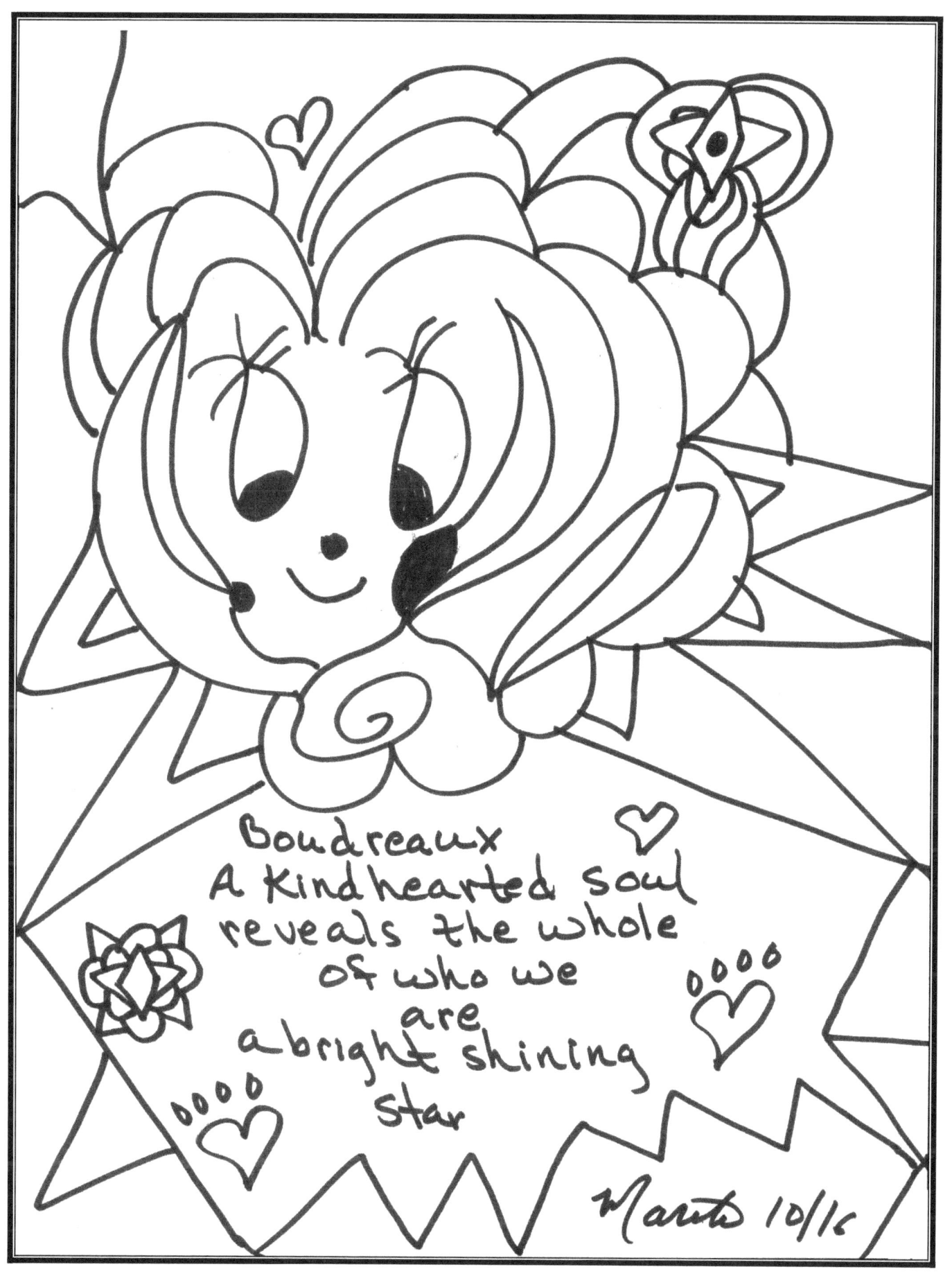

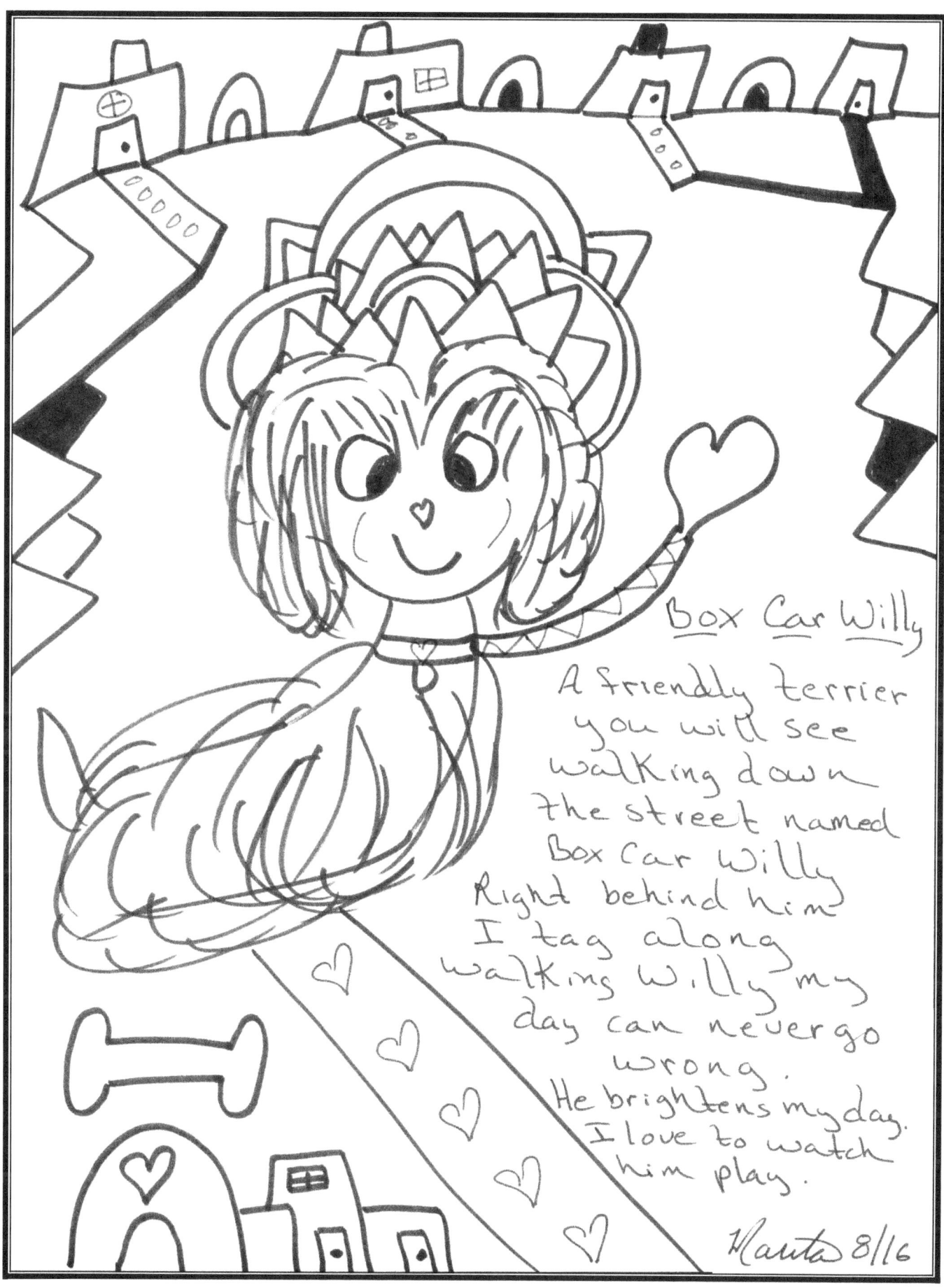

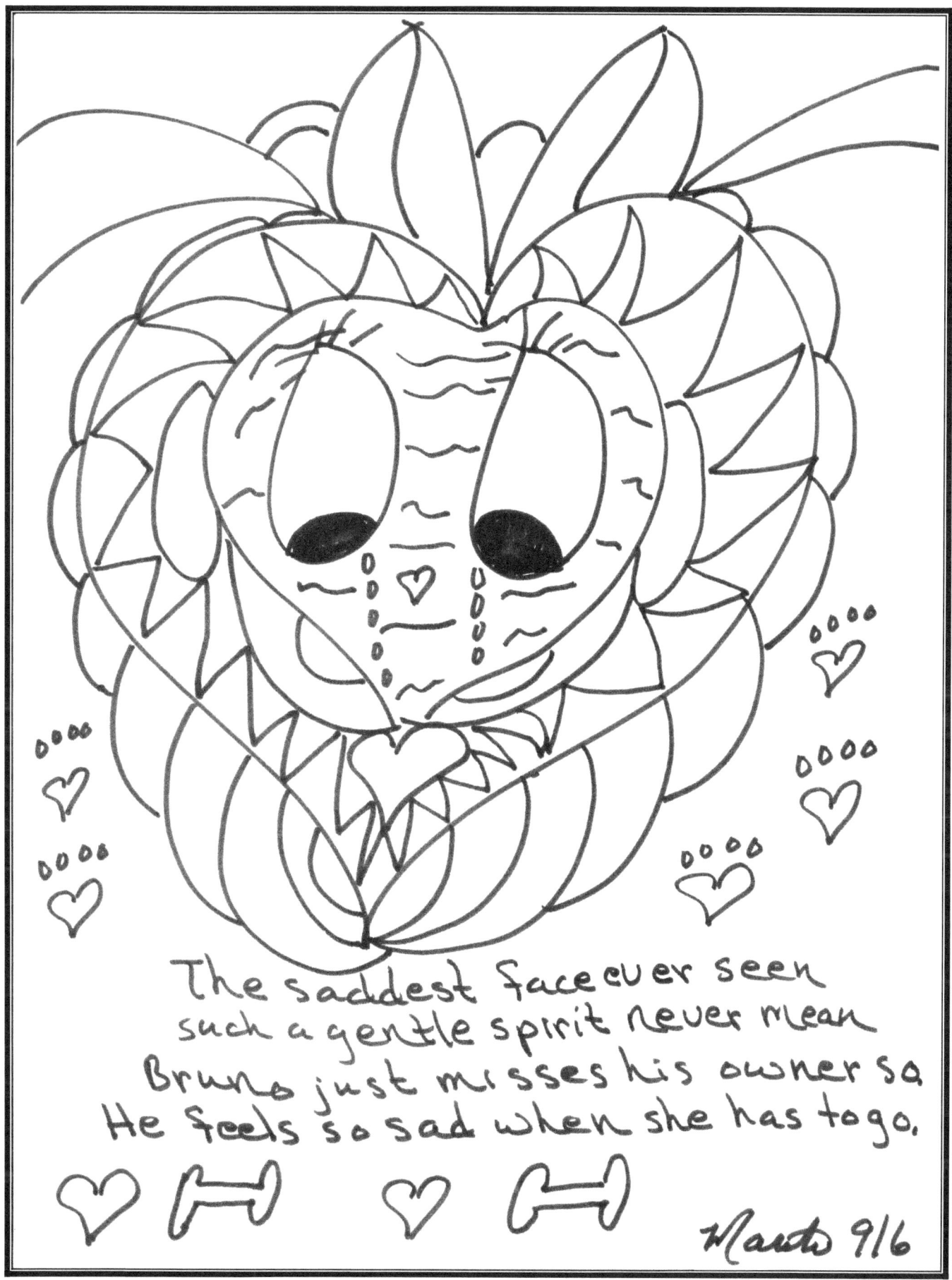

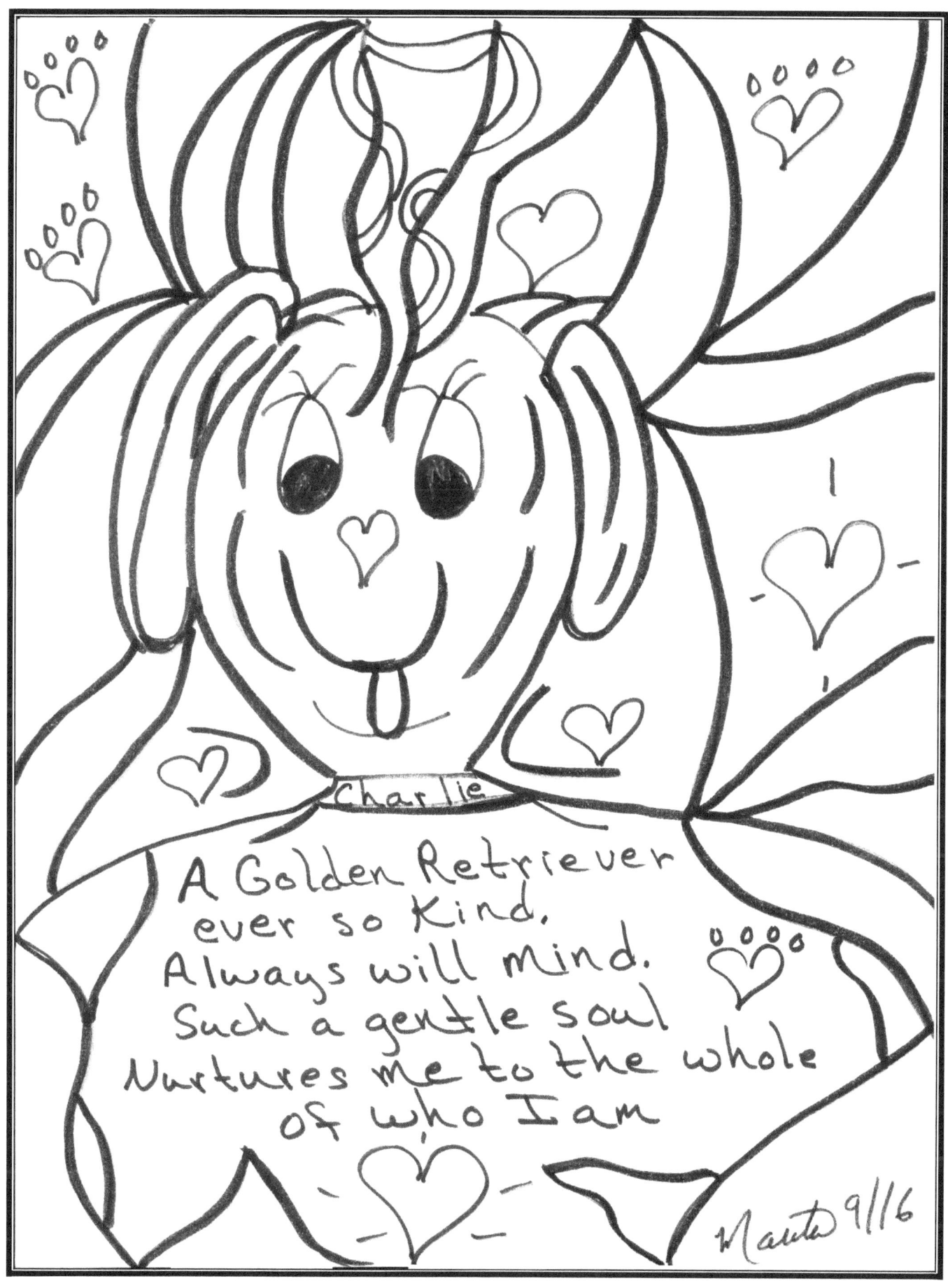

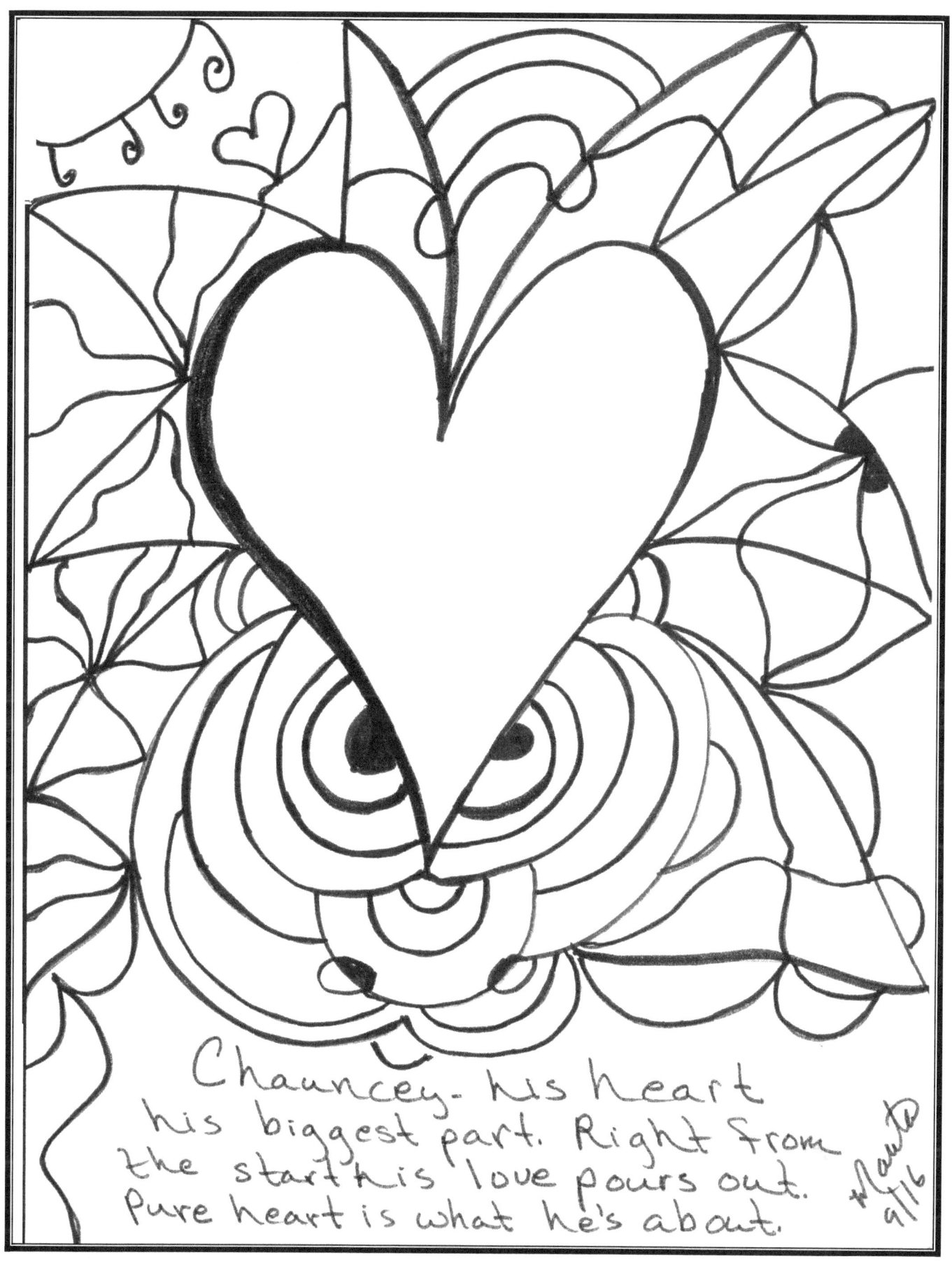

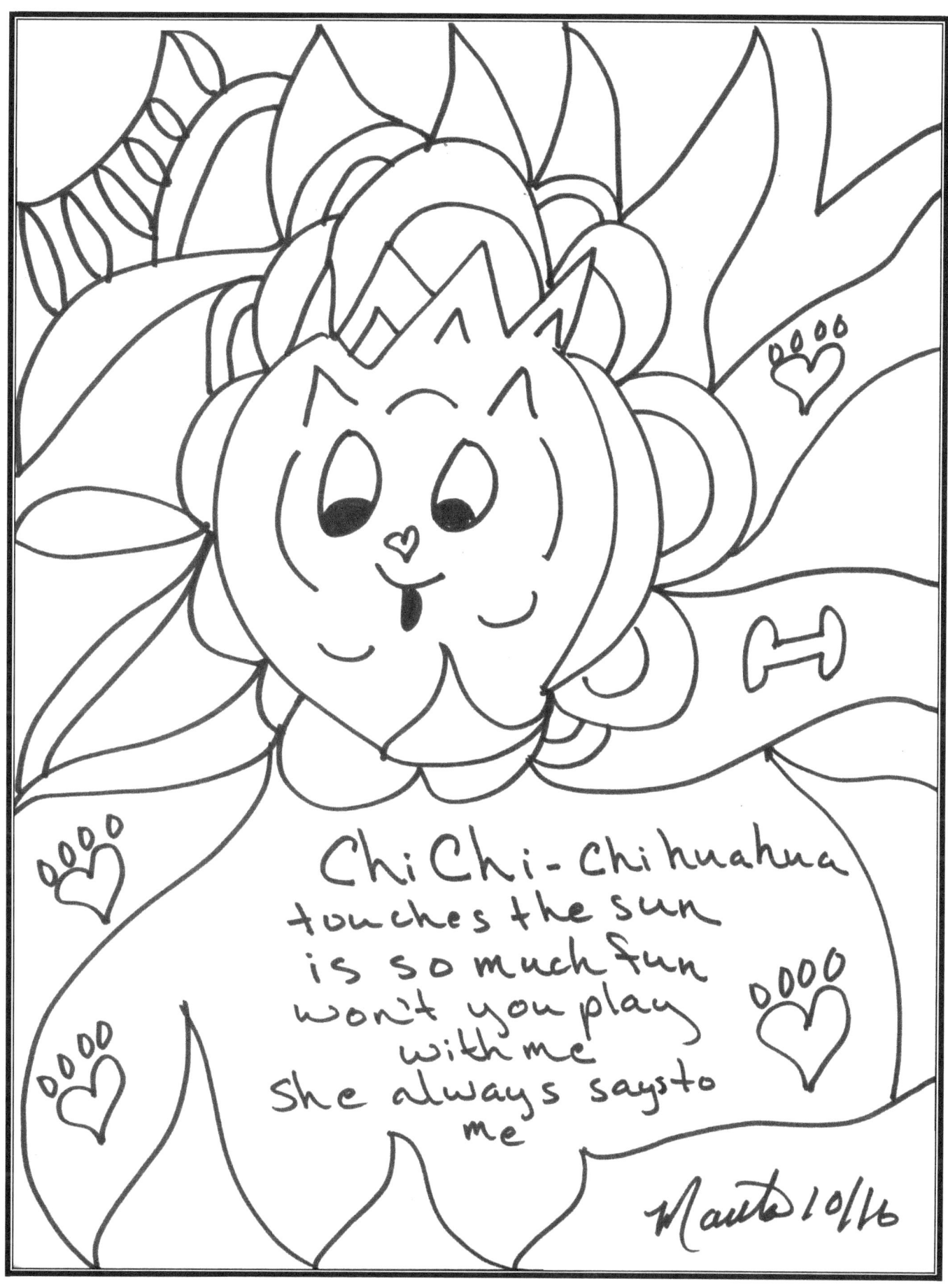

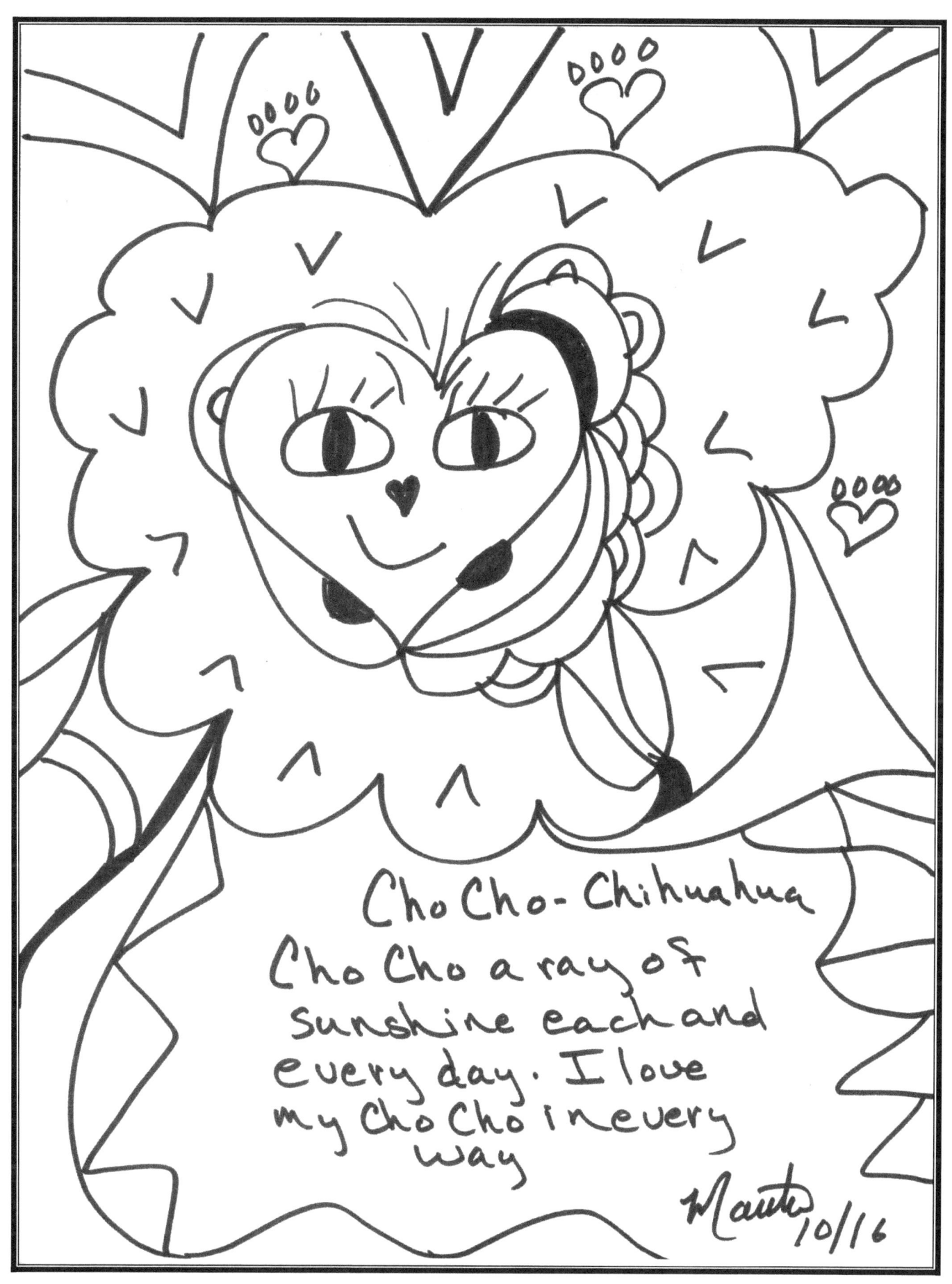

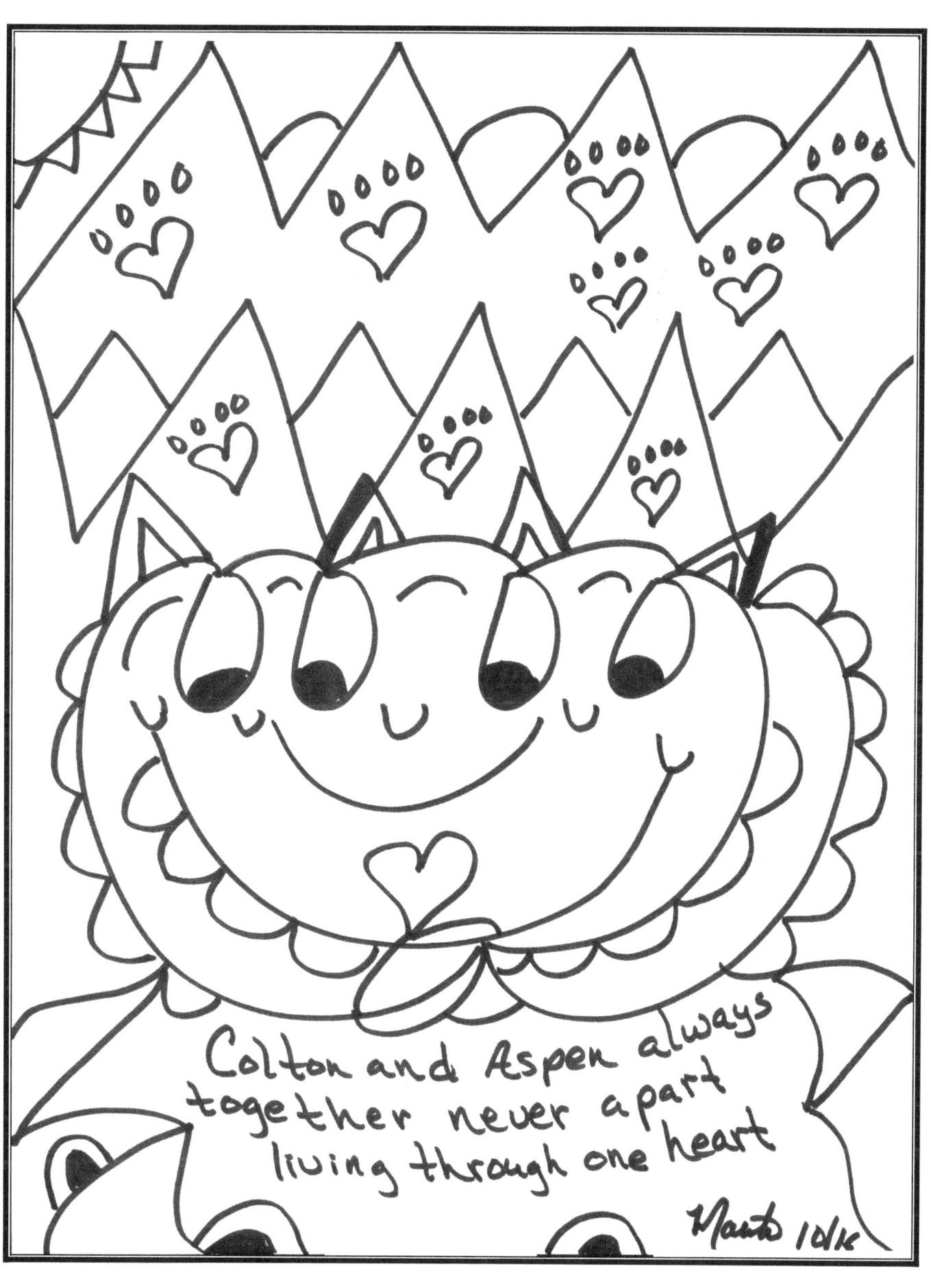

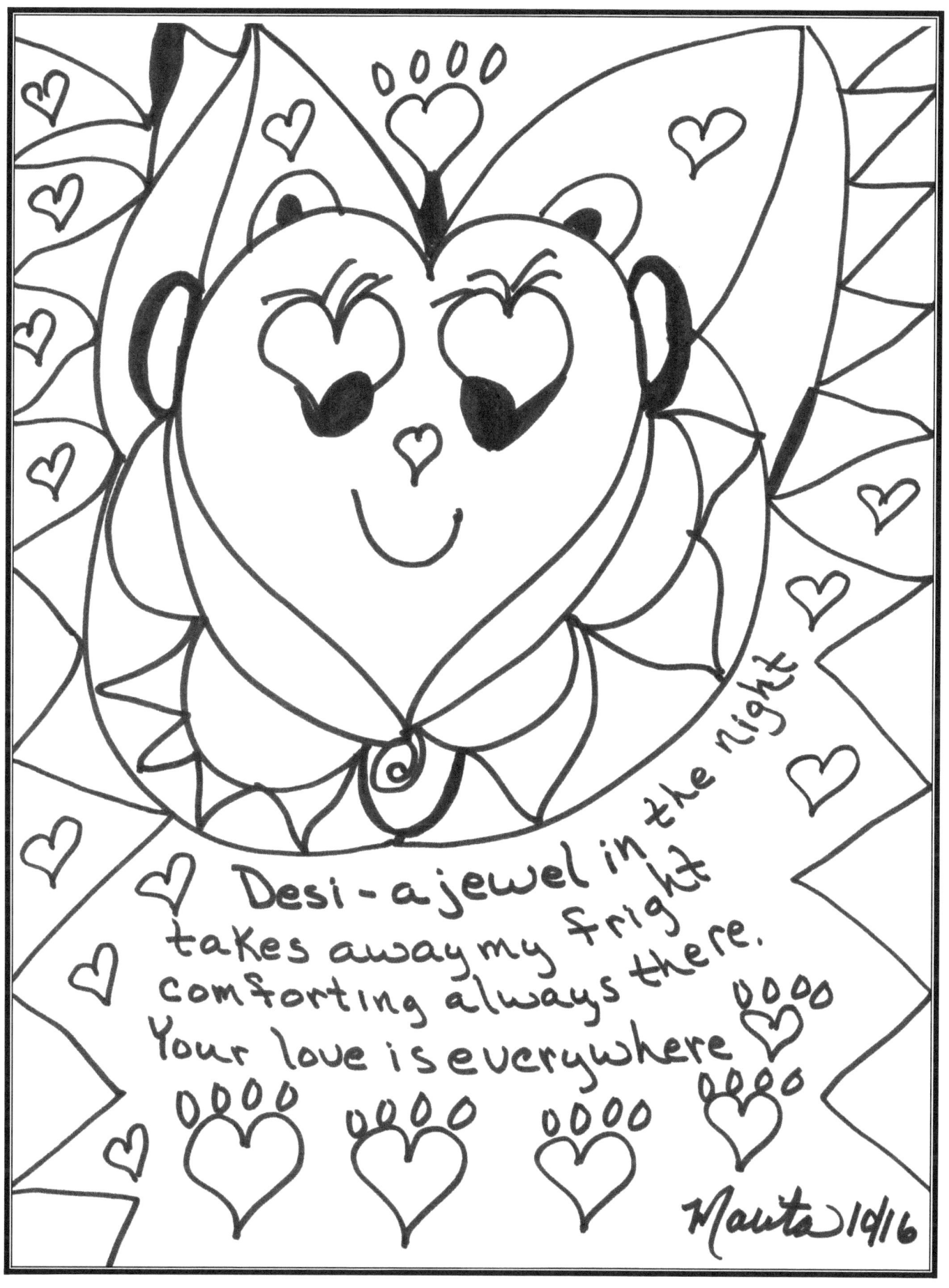

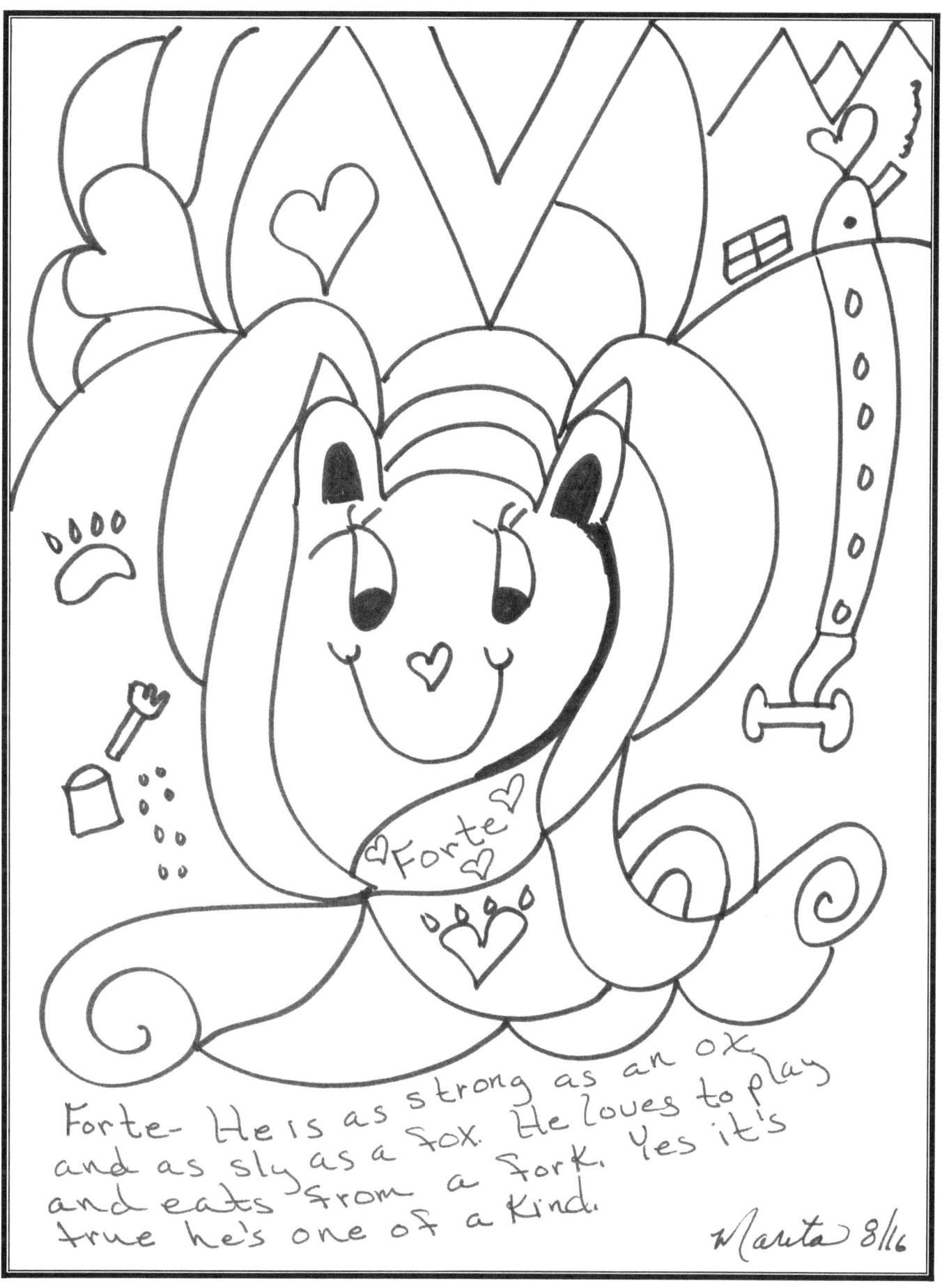

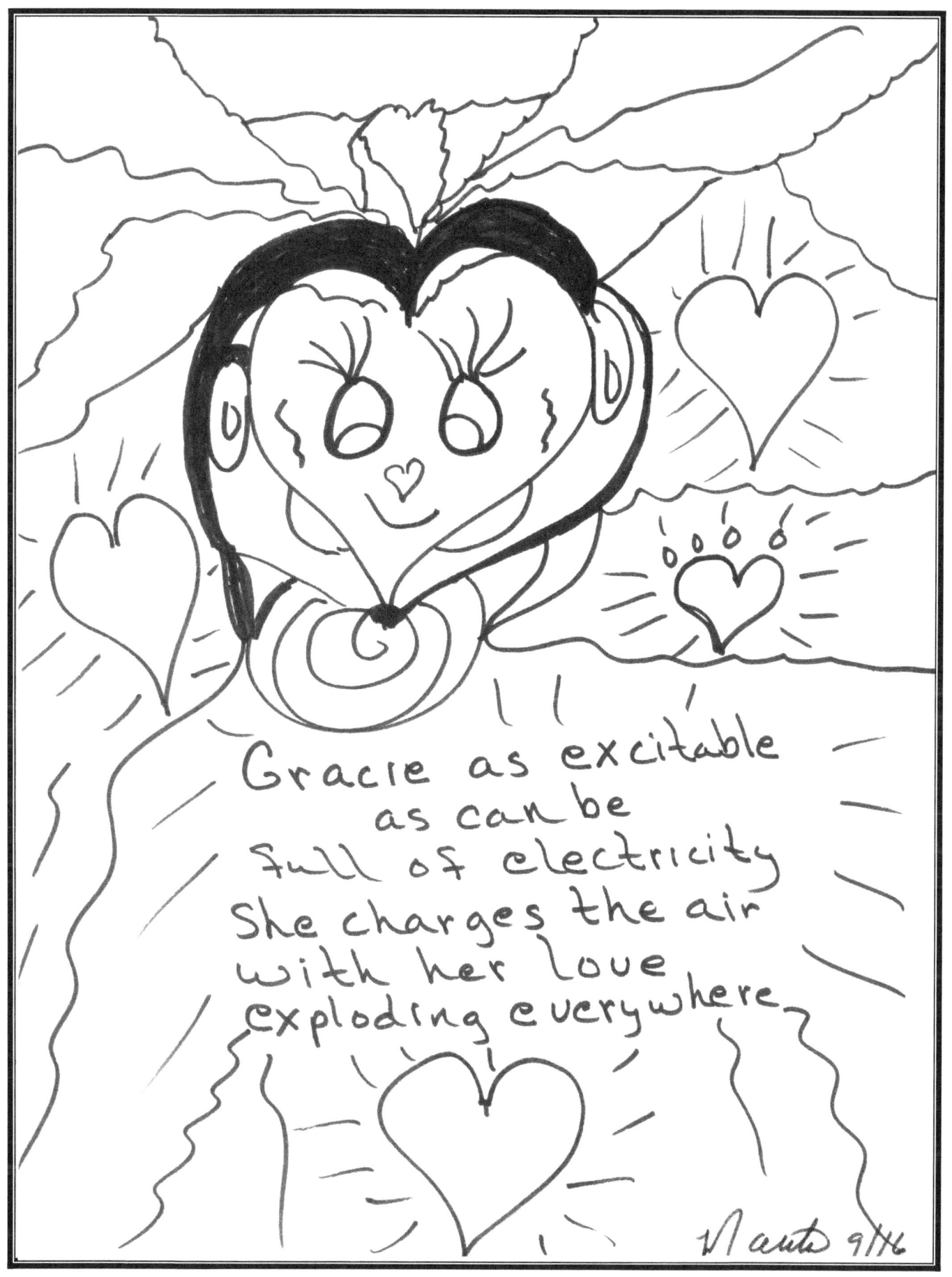

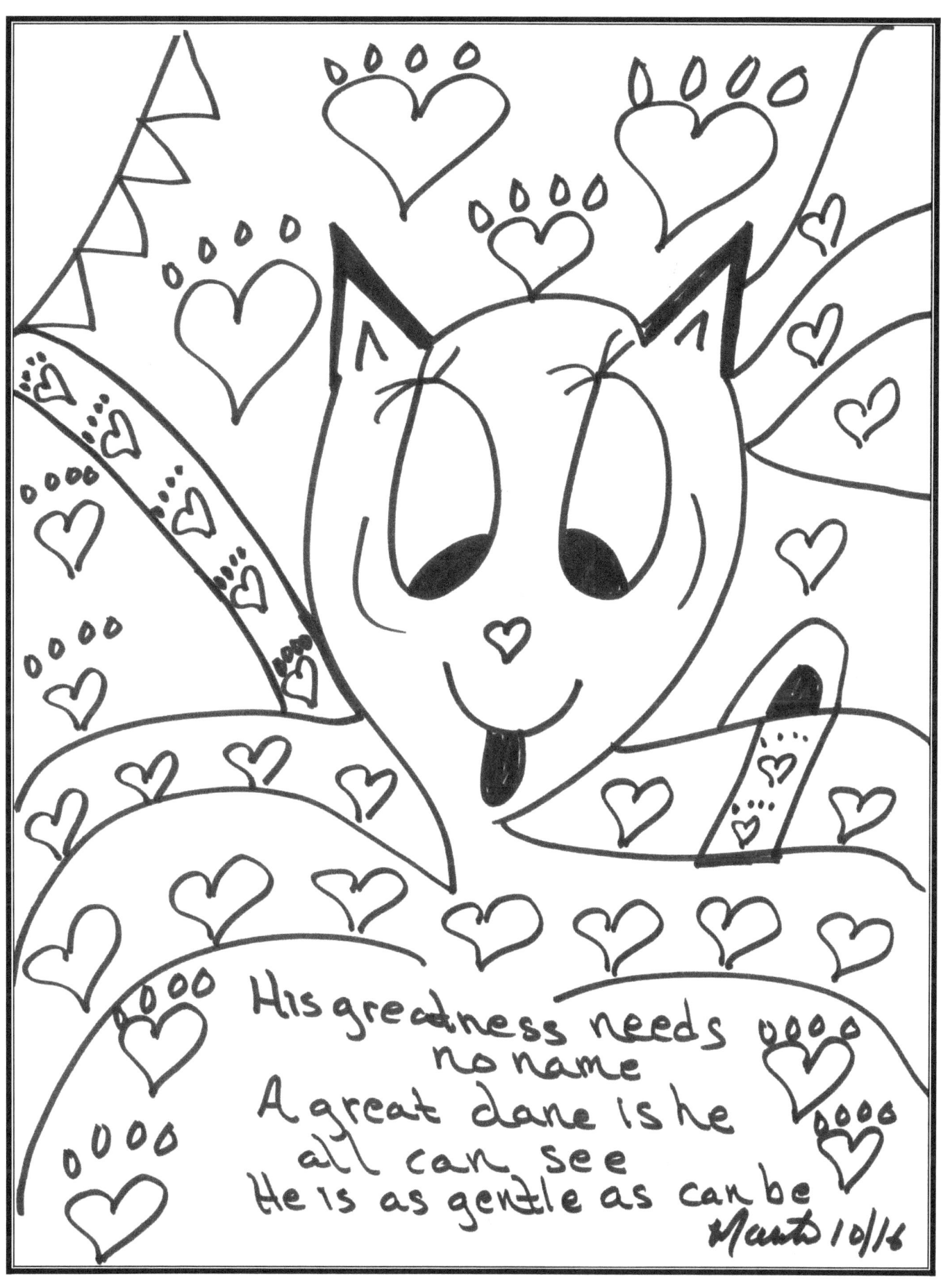

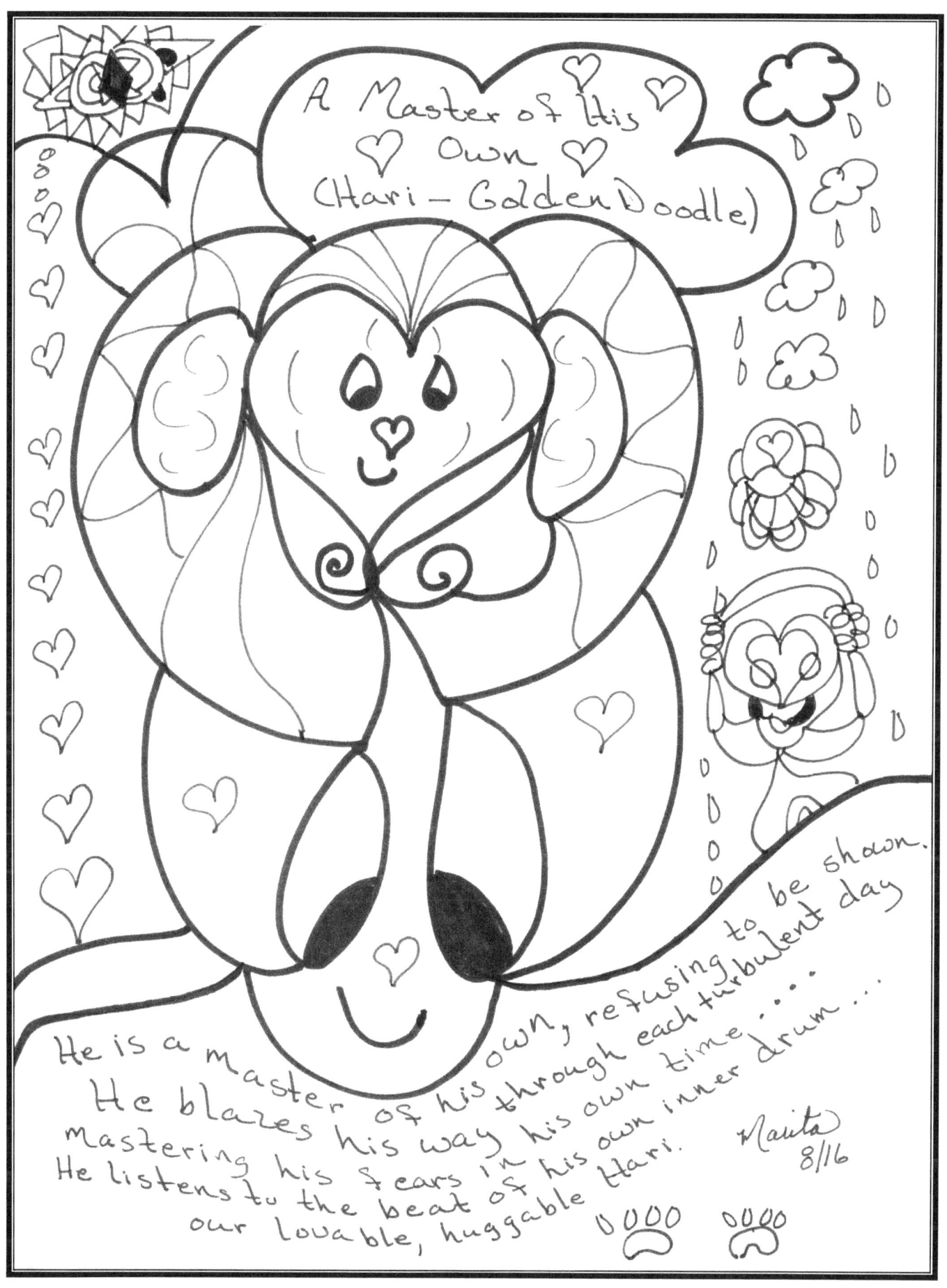

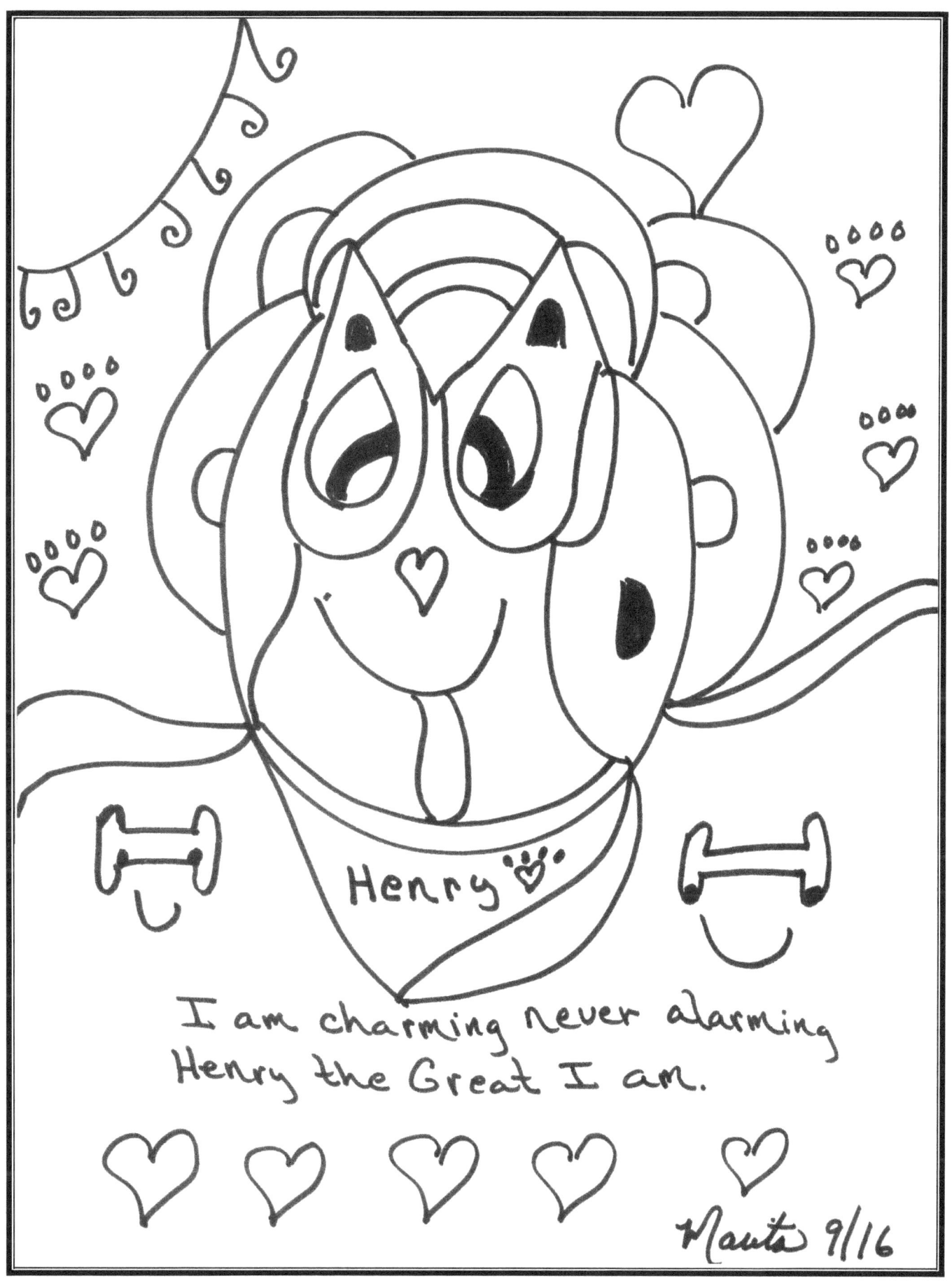

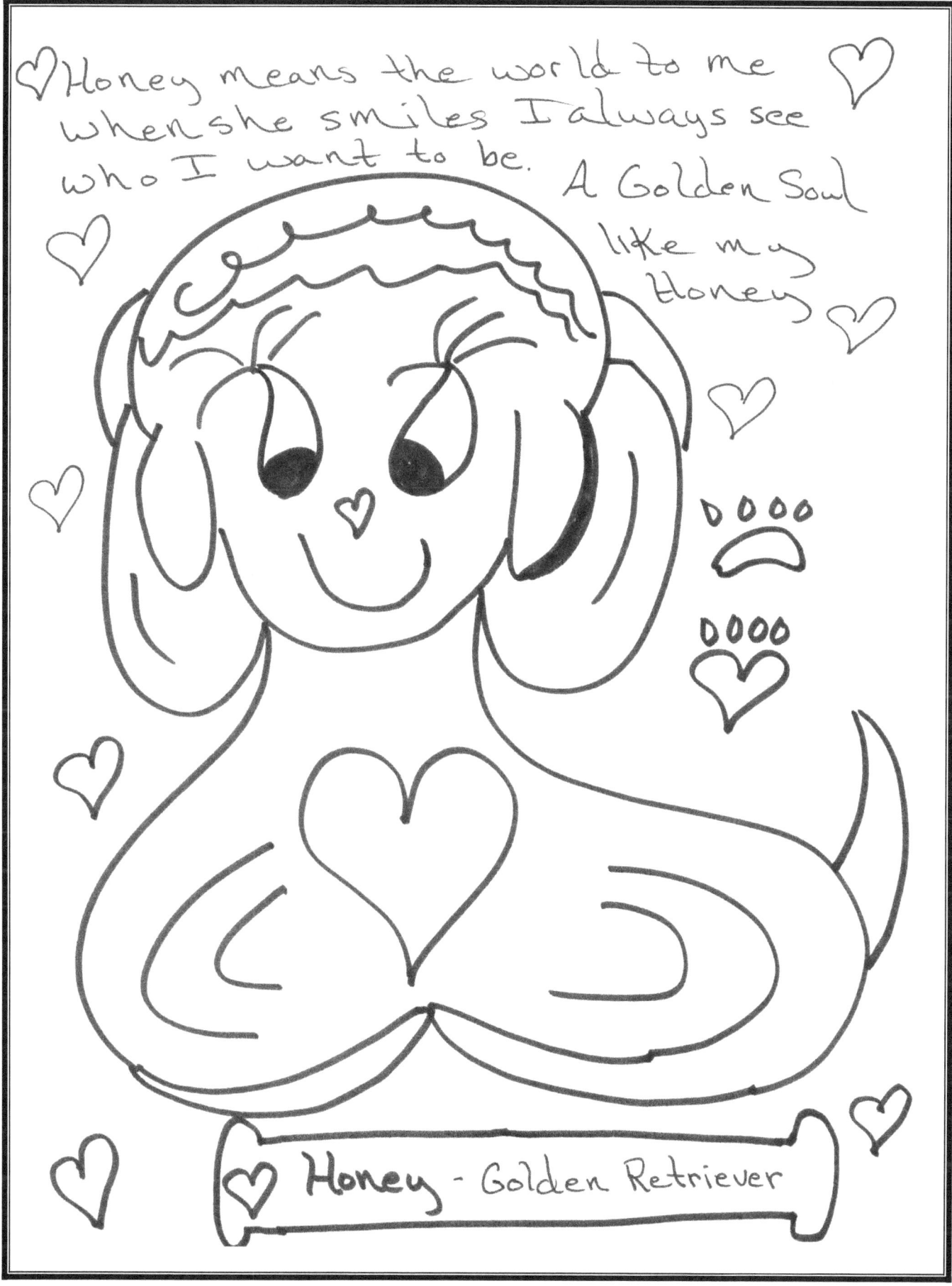

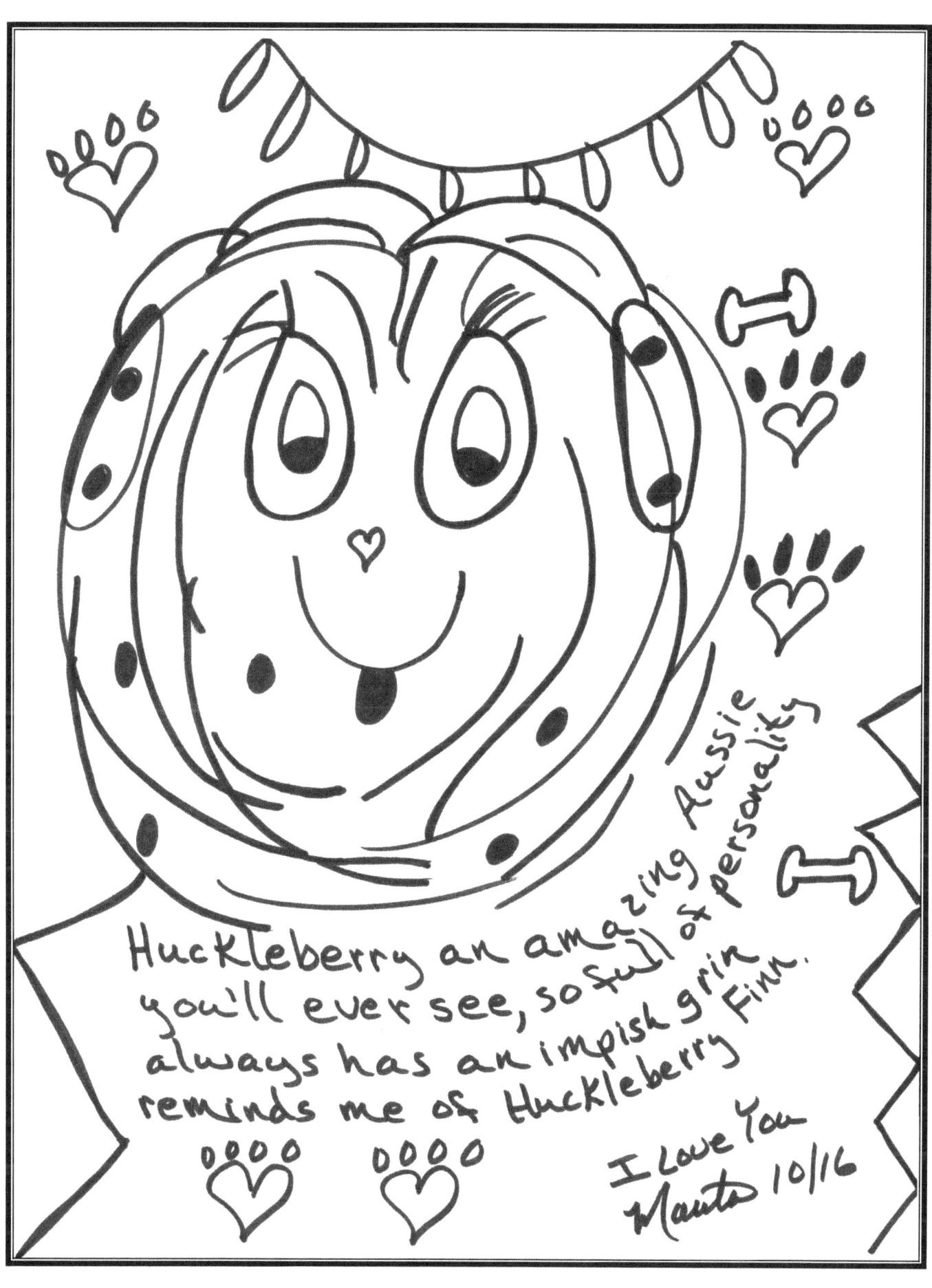

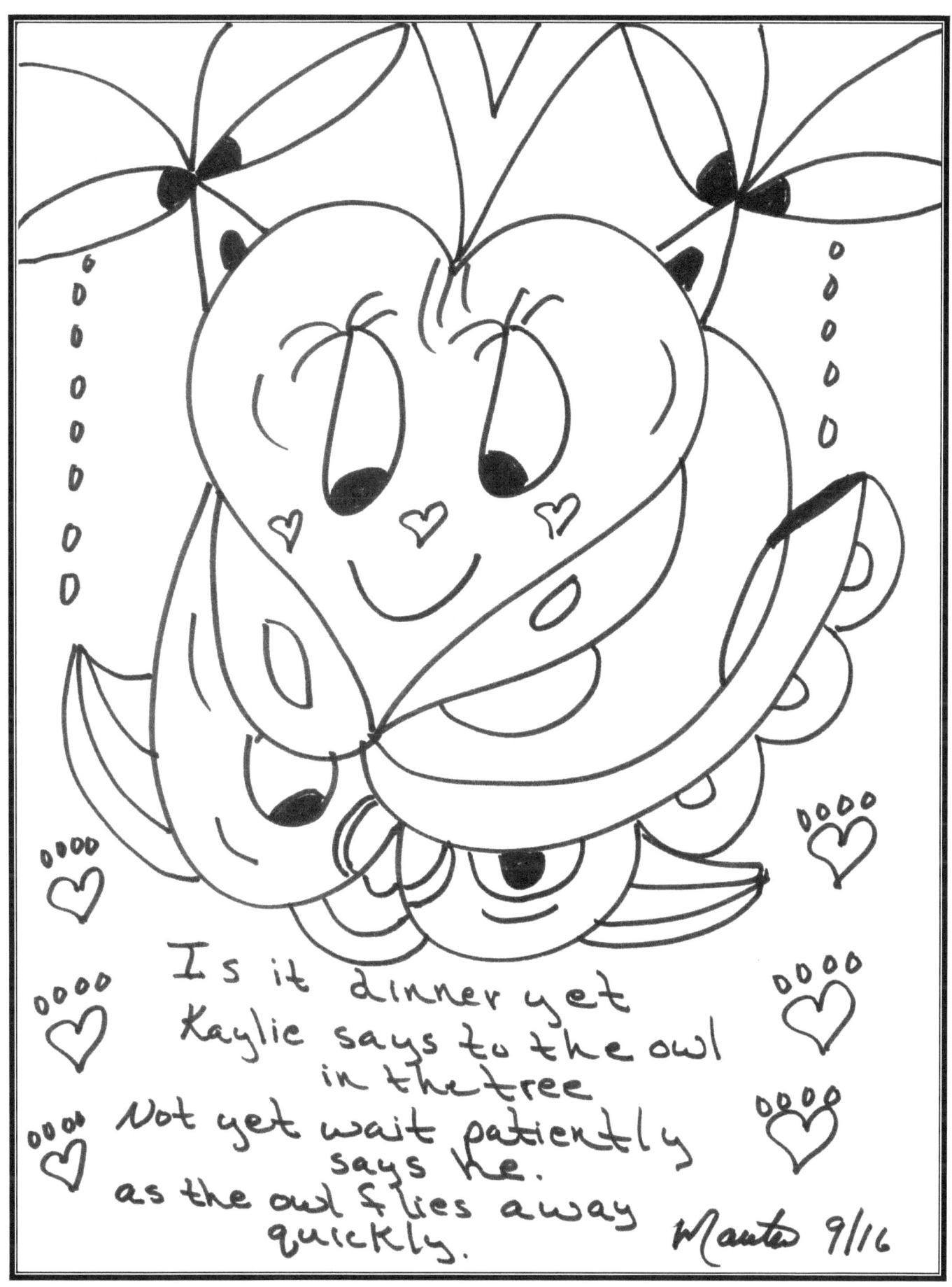

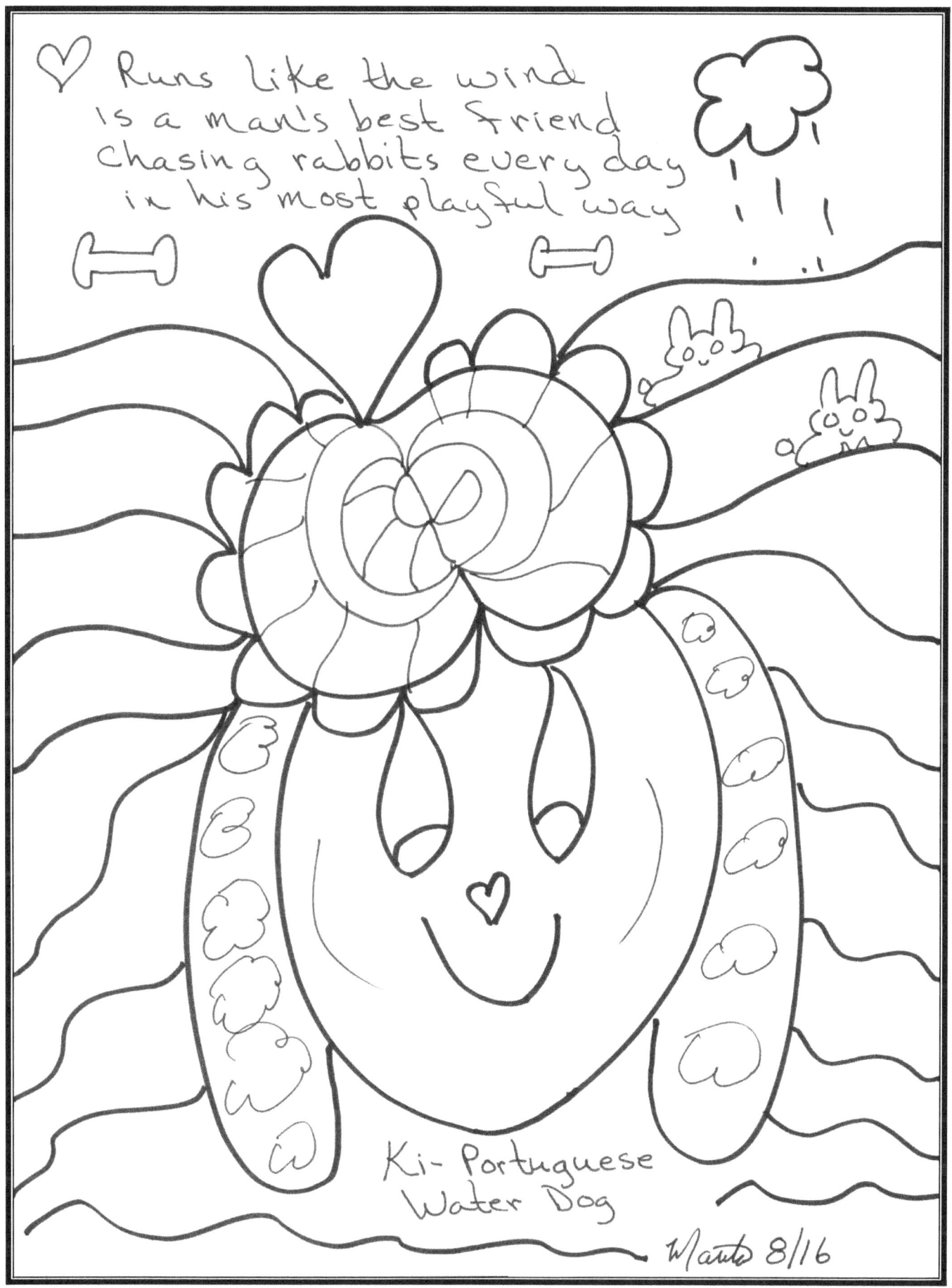

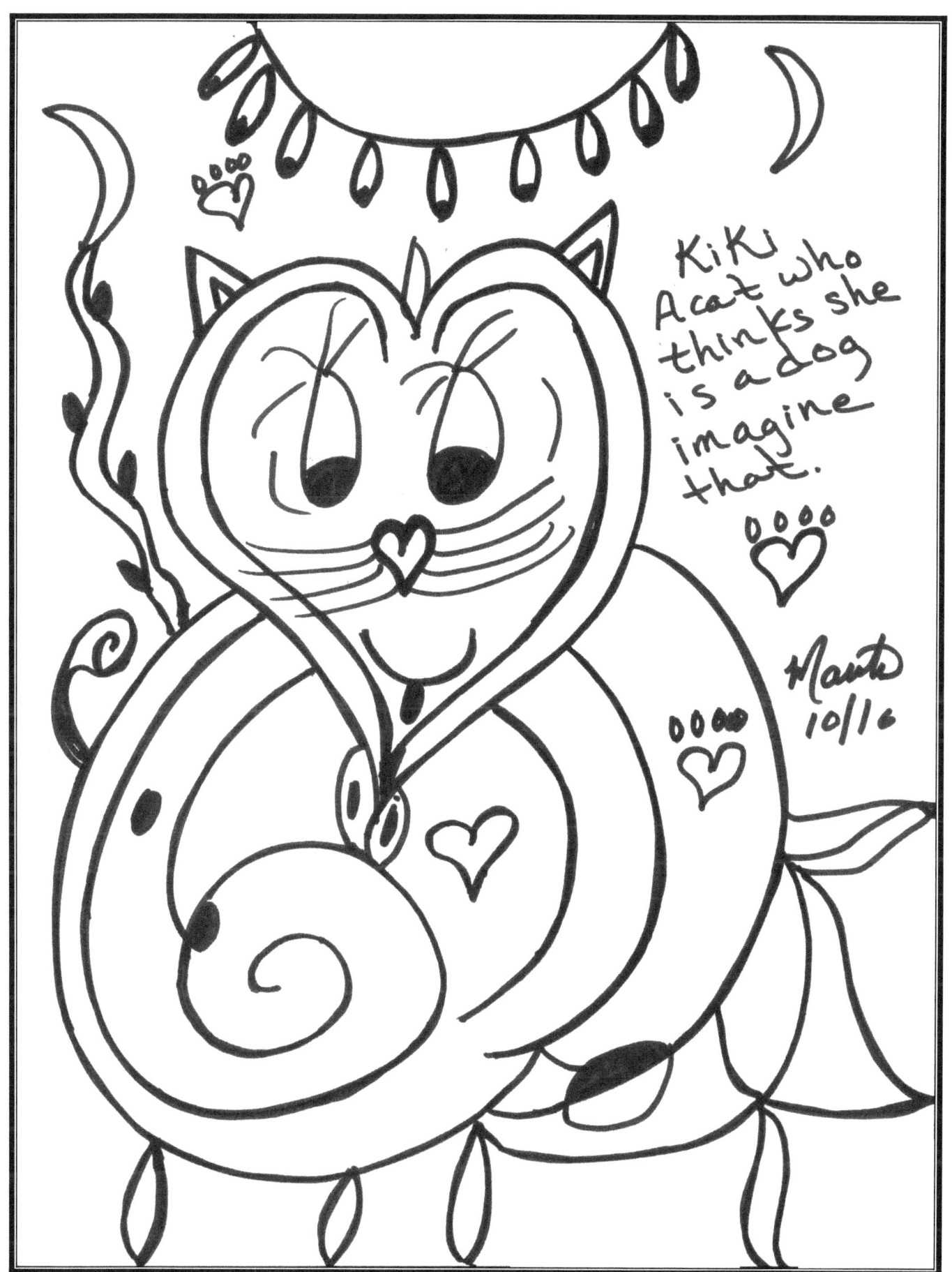

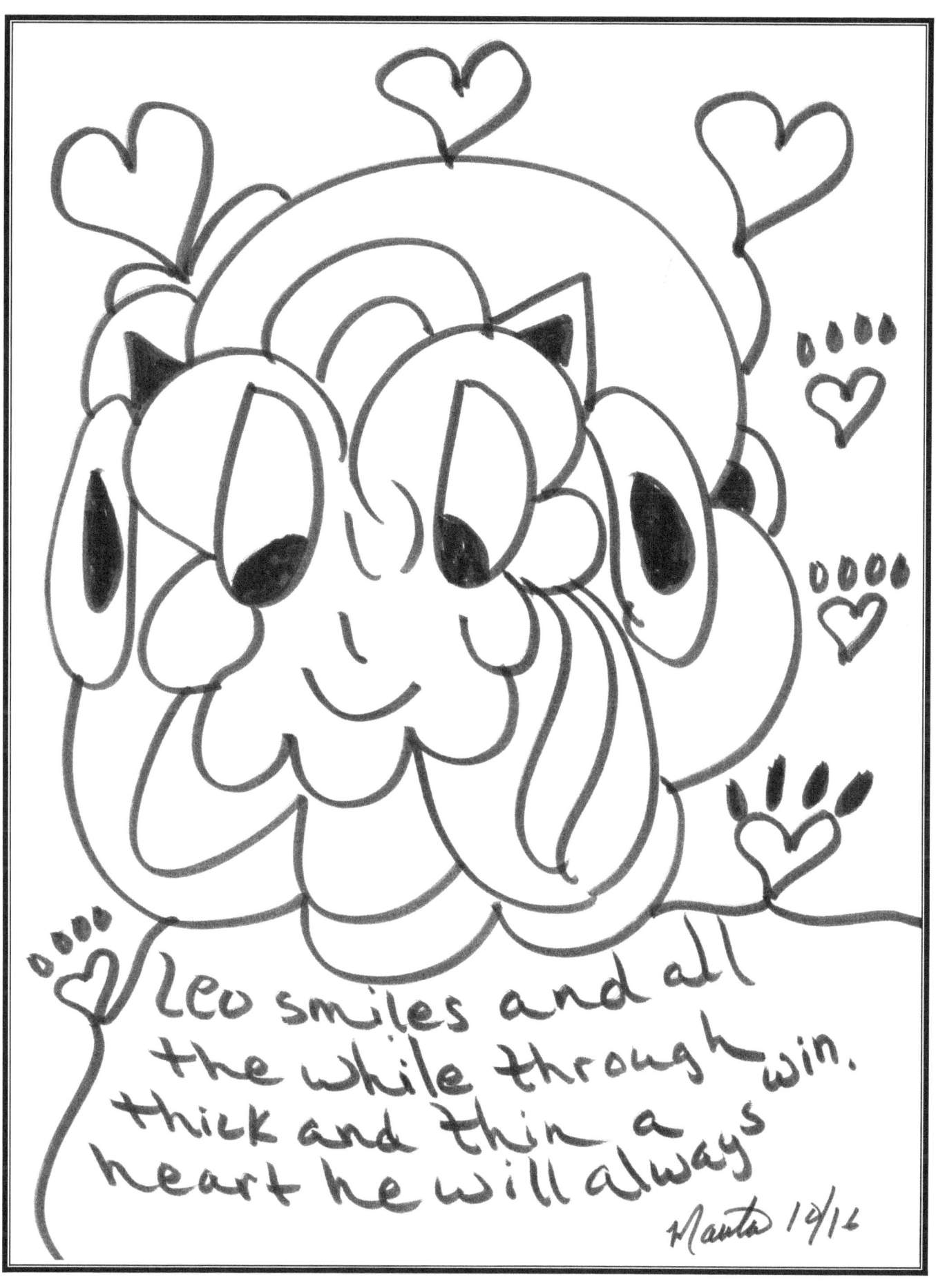

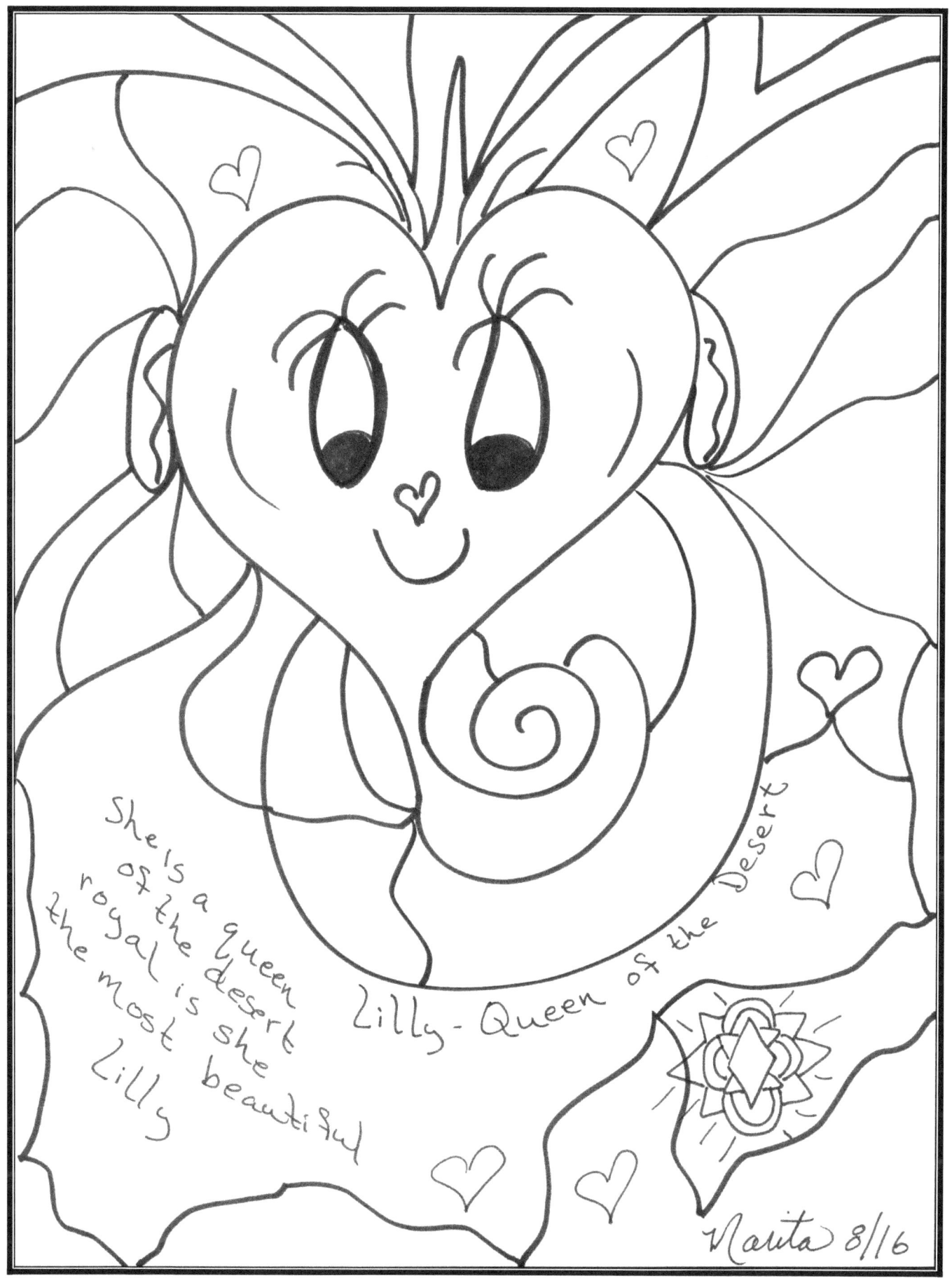

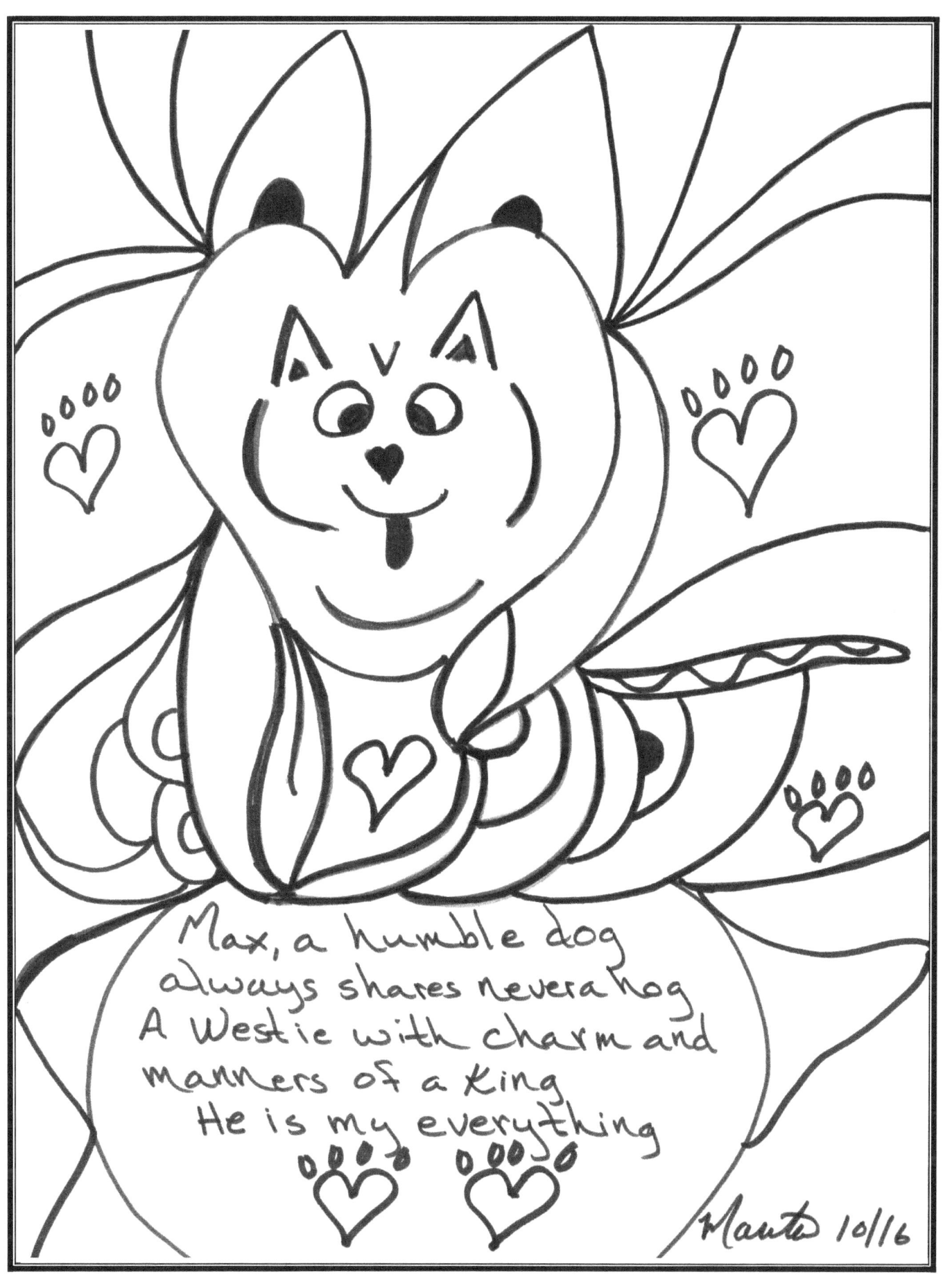

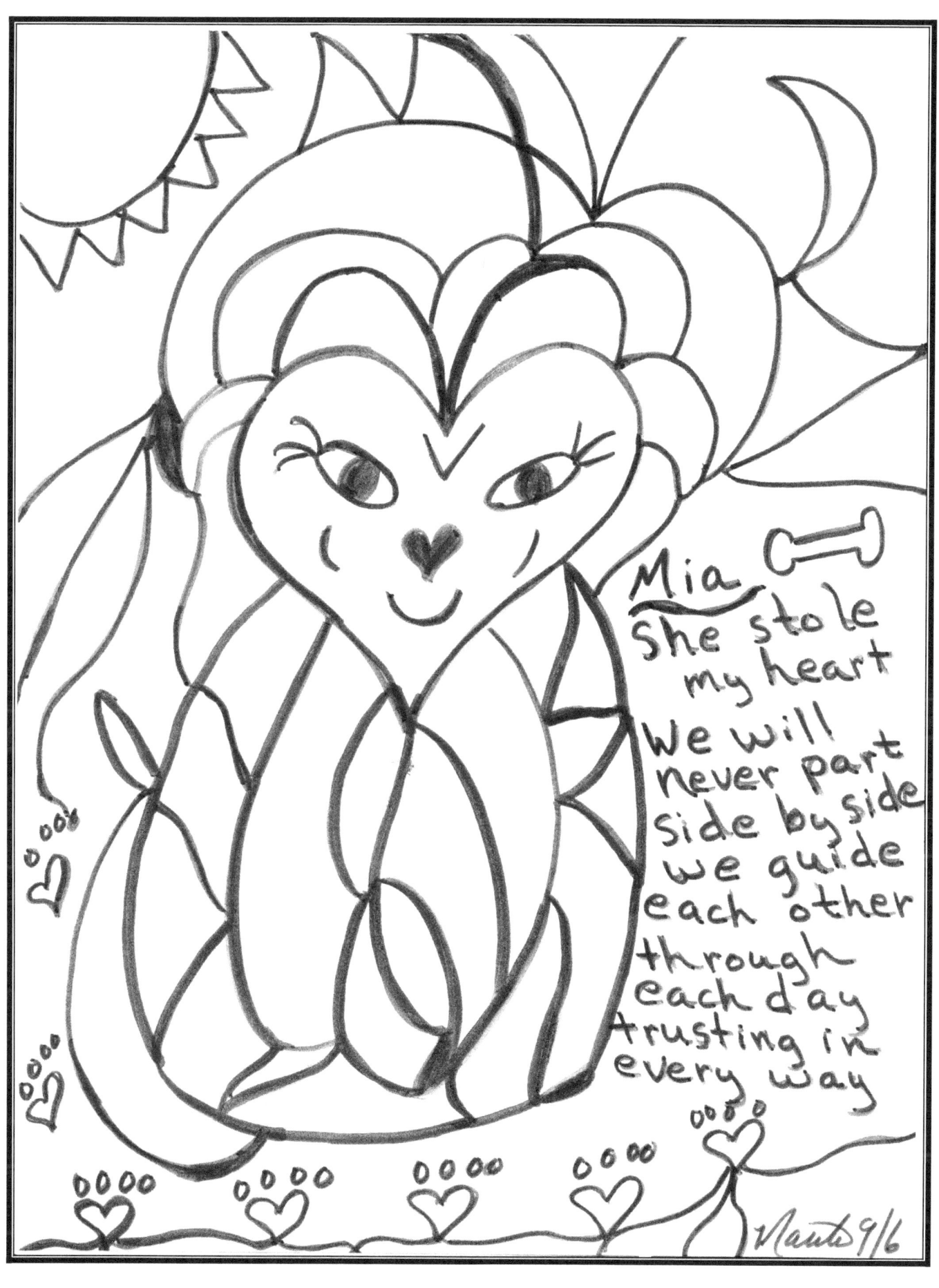

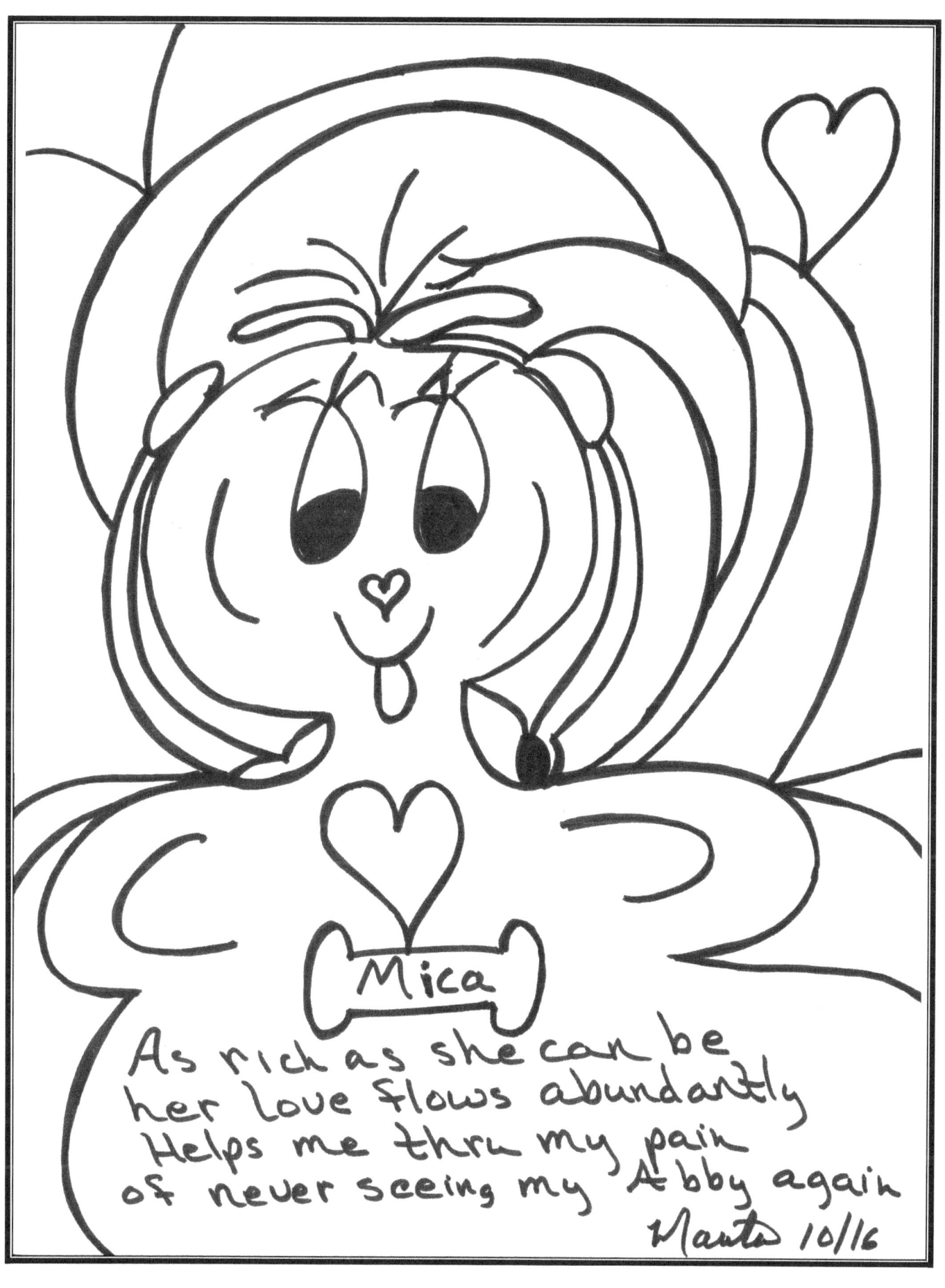

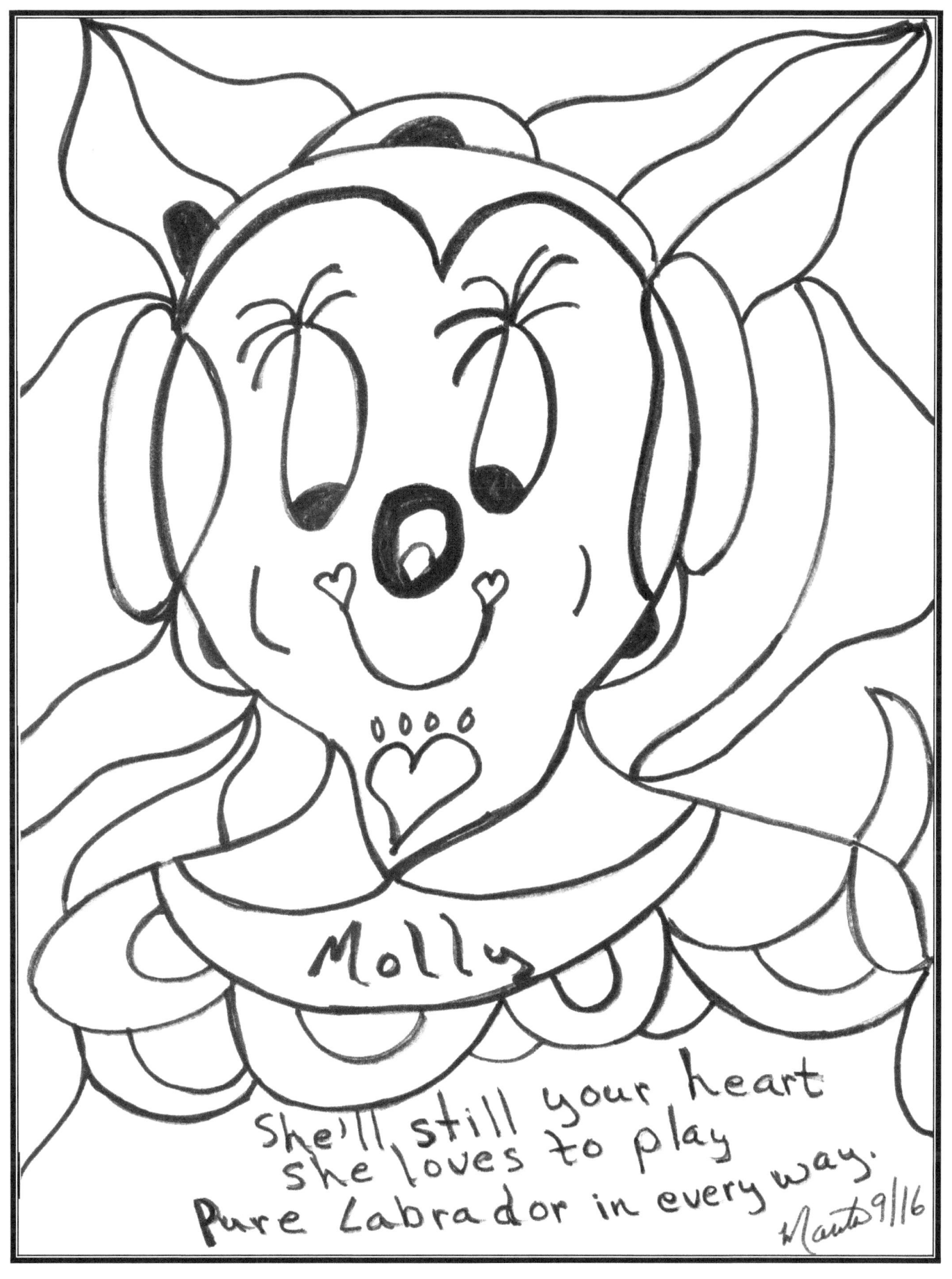

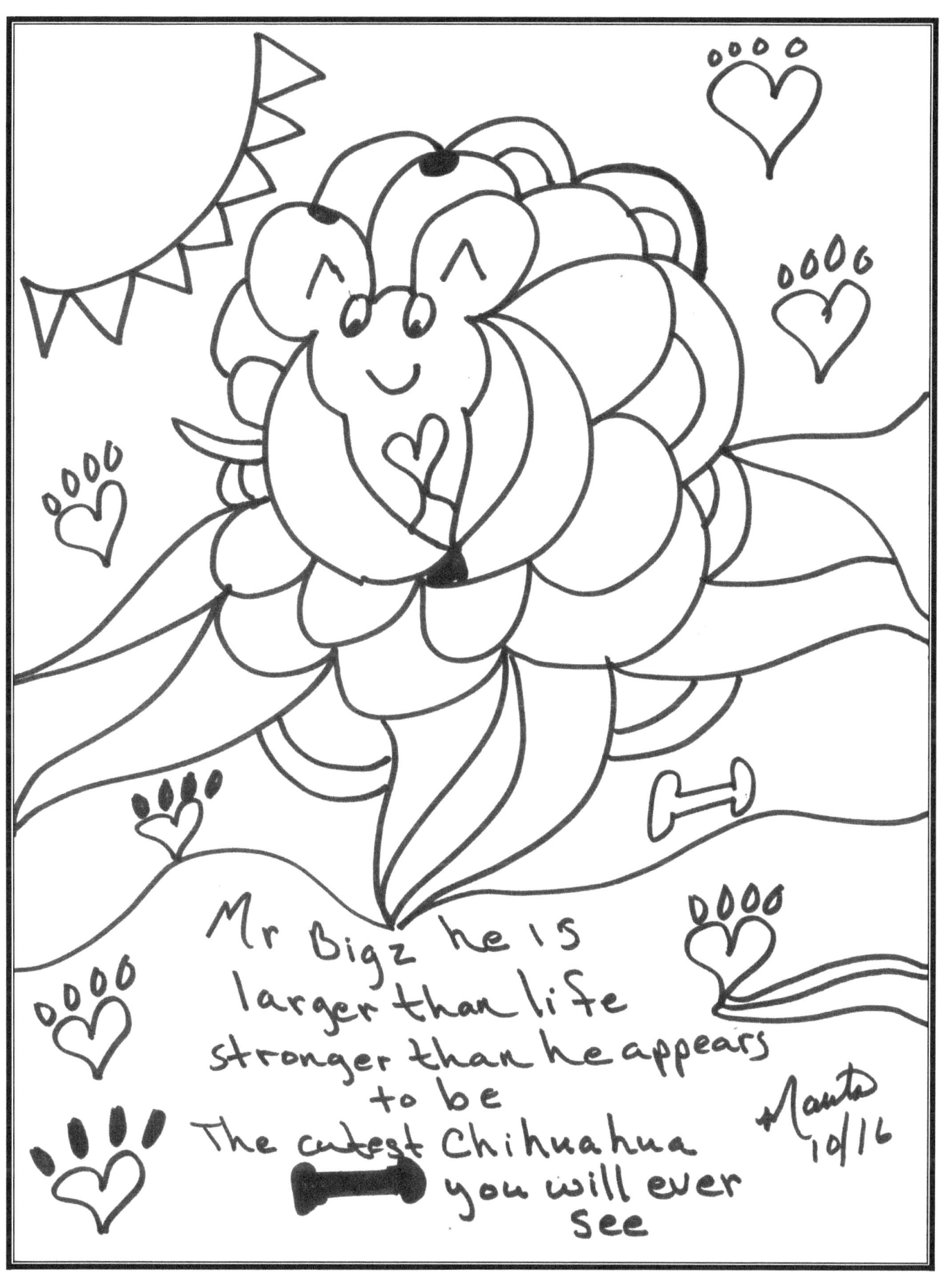

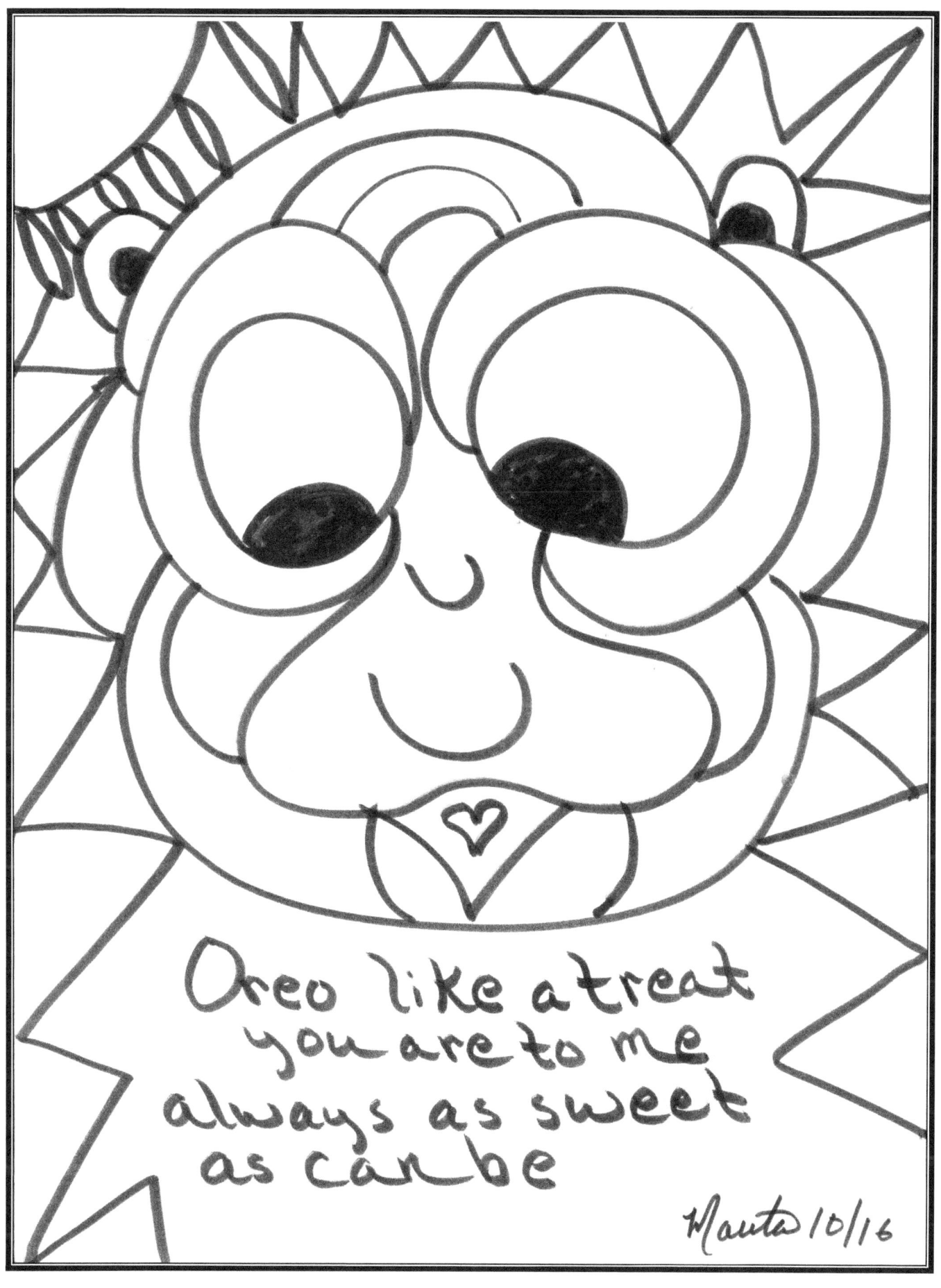

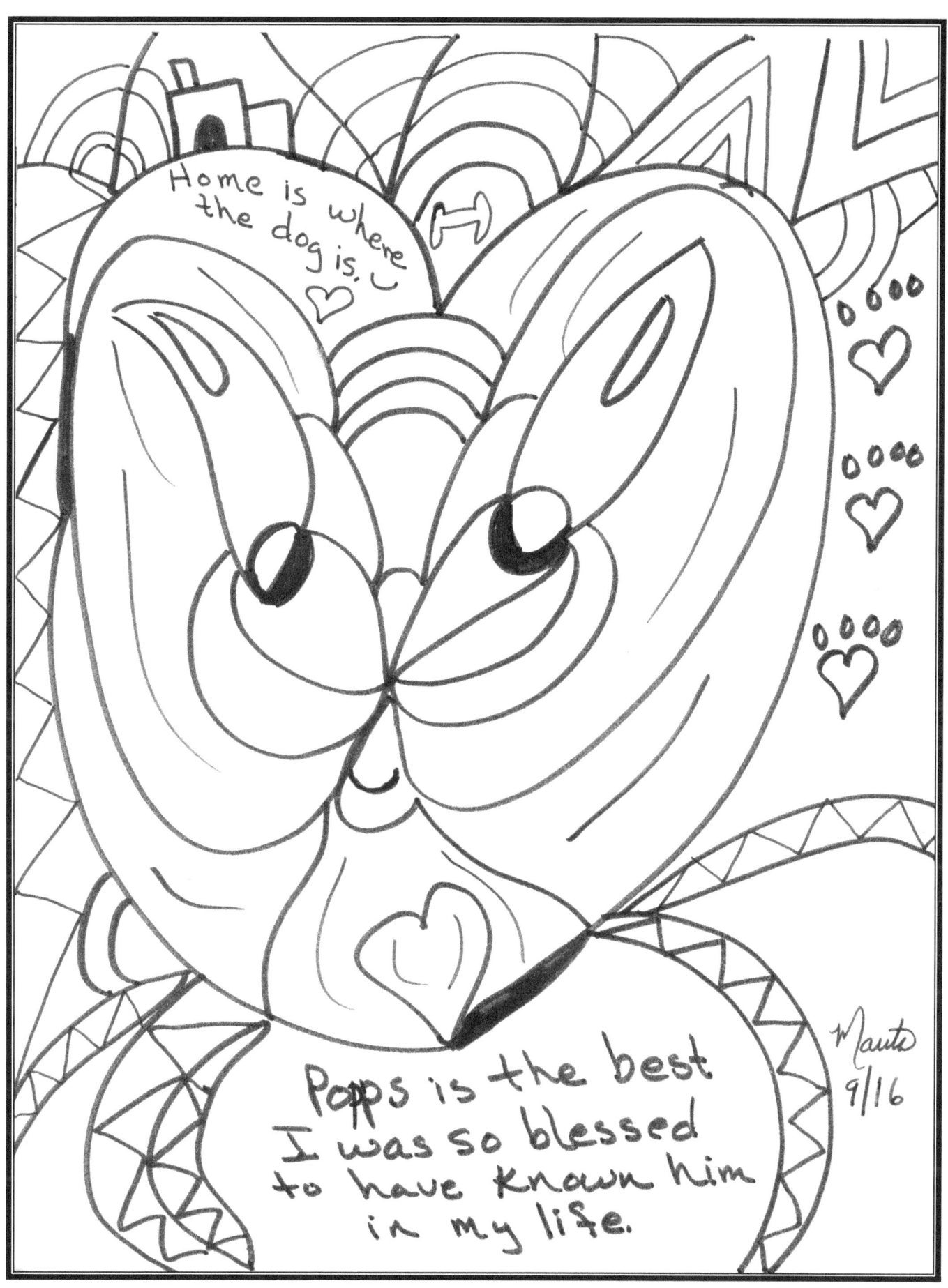

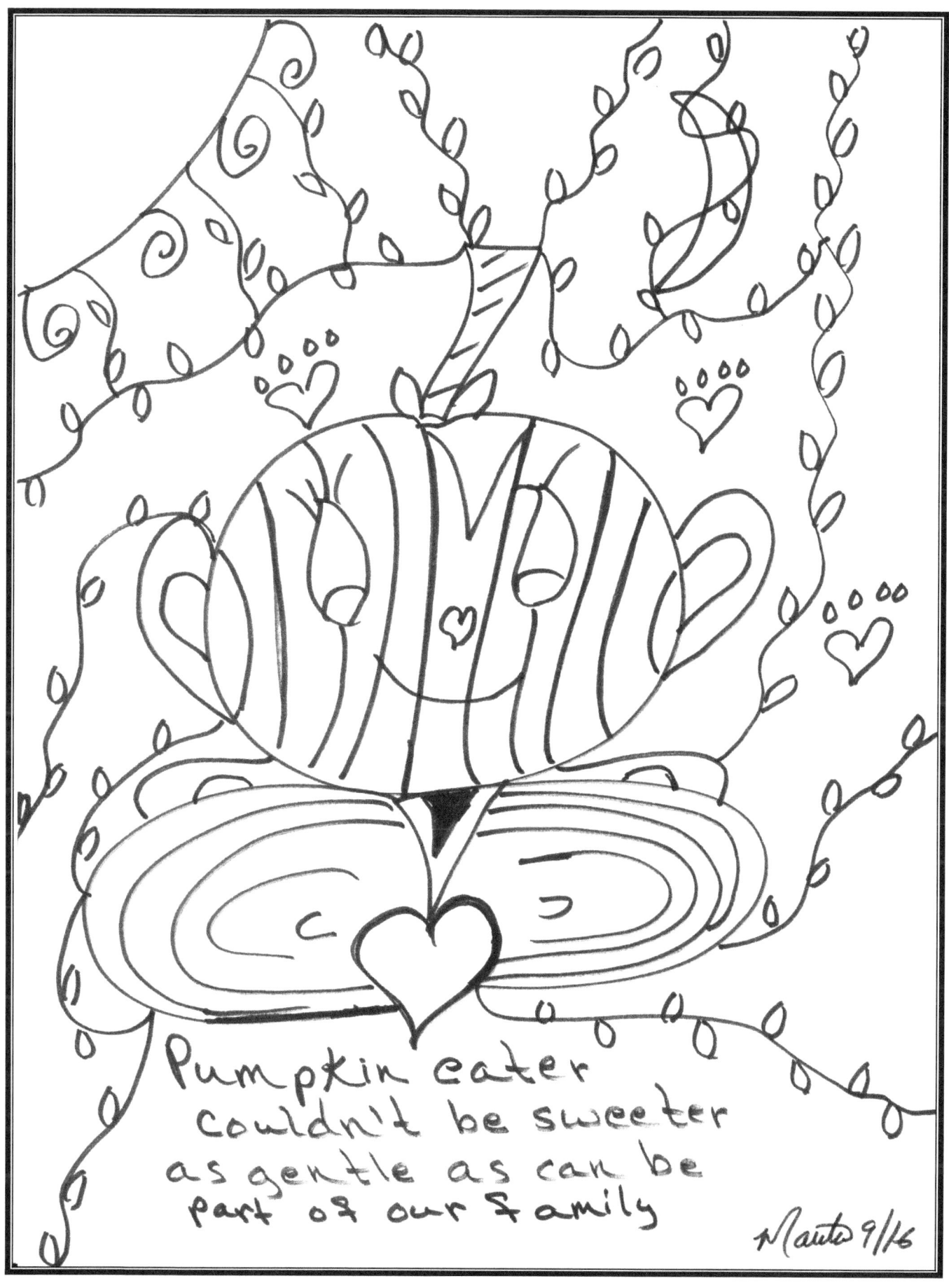

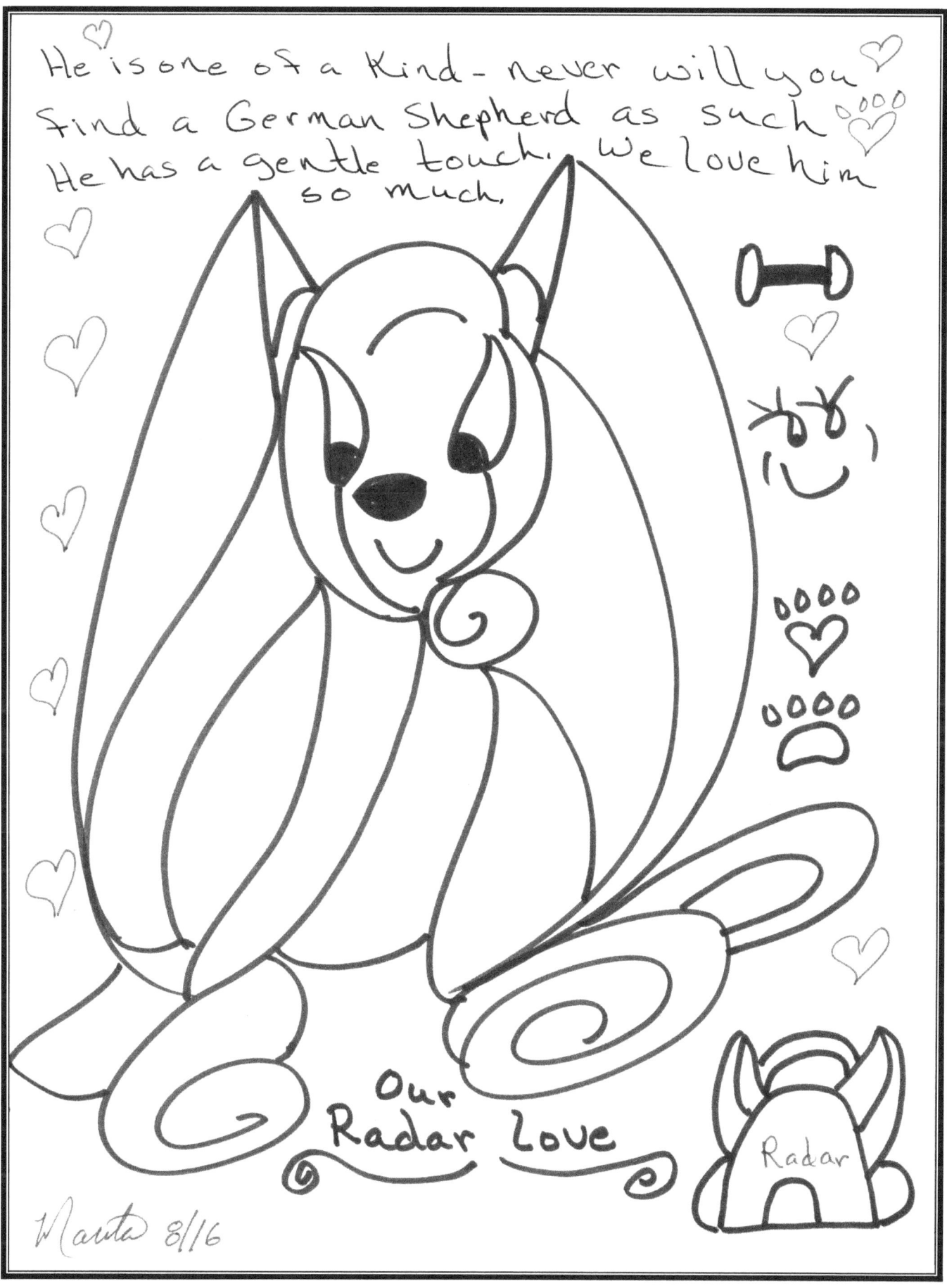

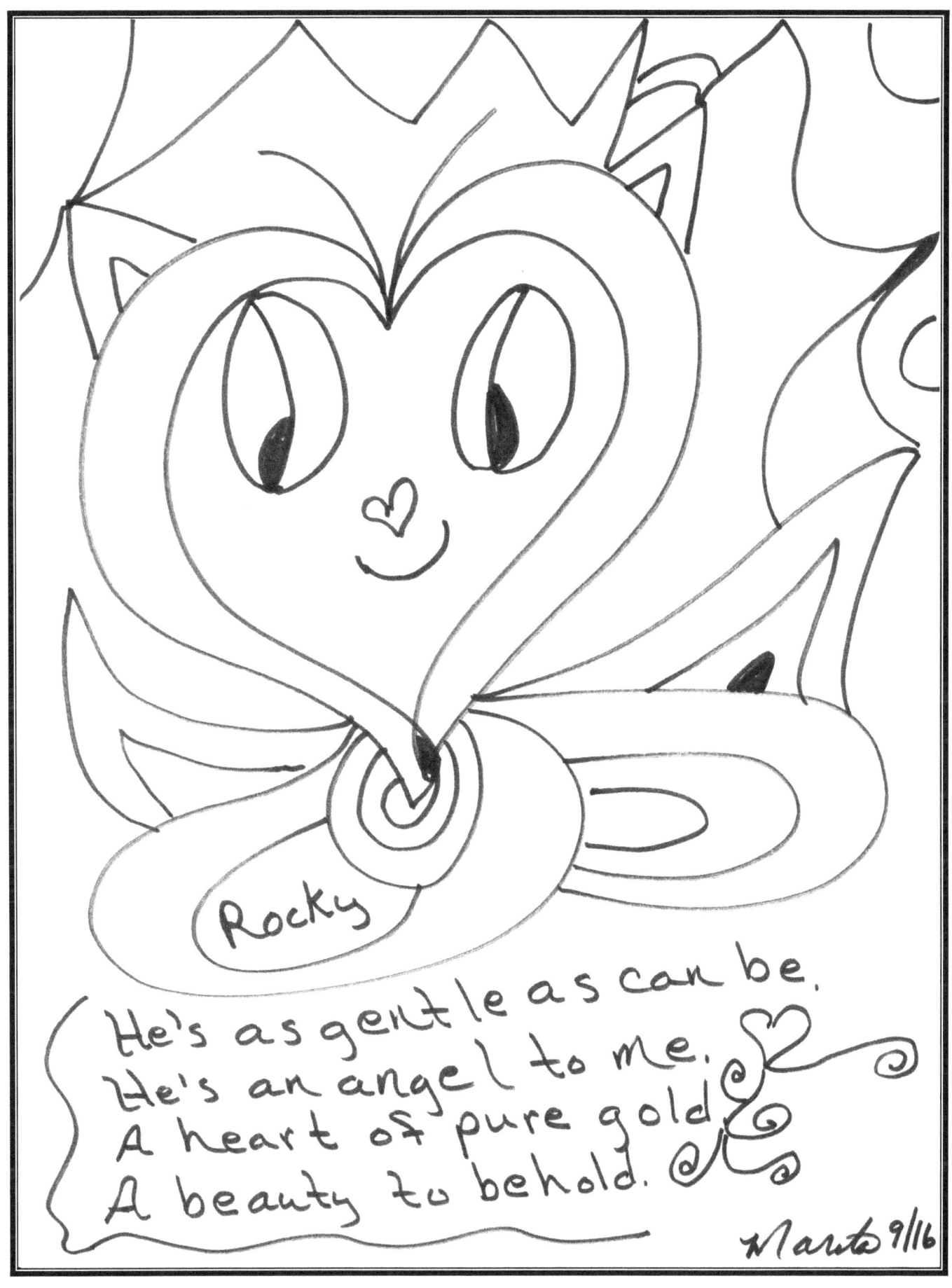

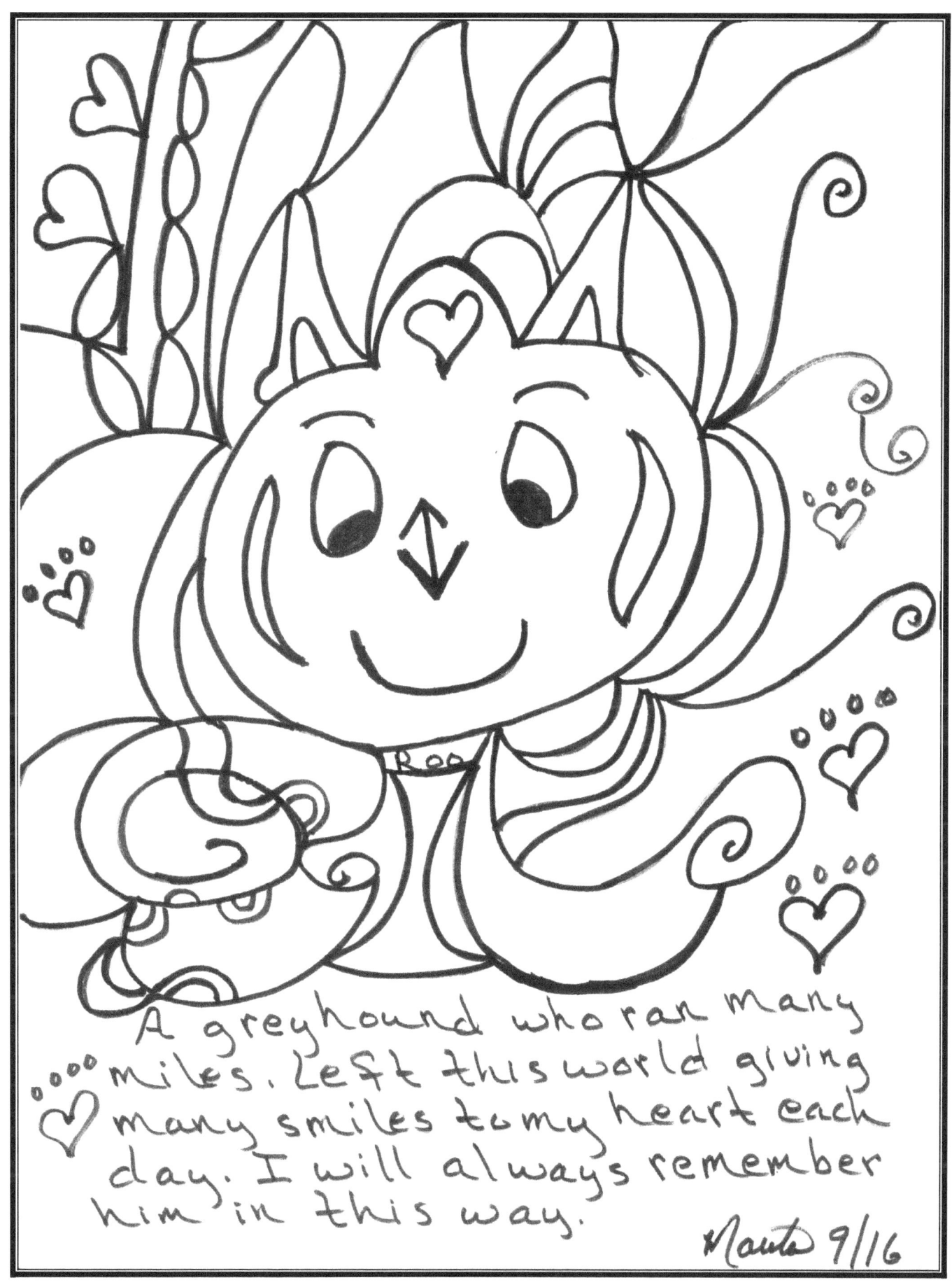

A greyhound who ran many miles. Left this world giving many smiles to my heart each day. I will always remember him in this way.

Marta 9/16

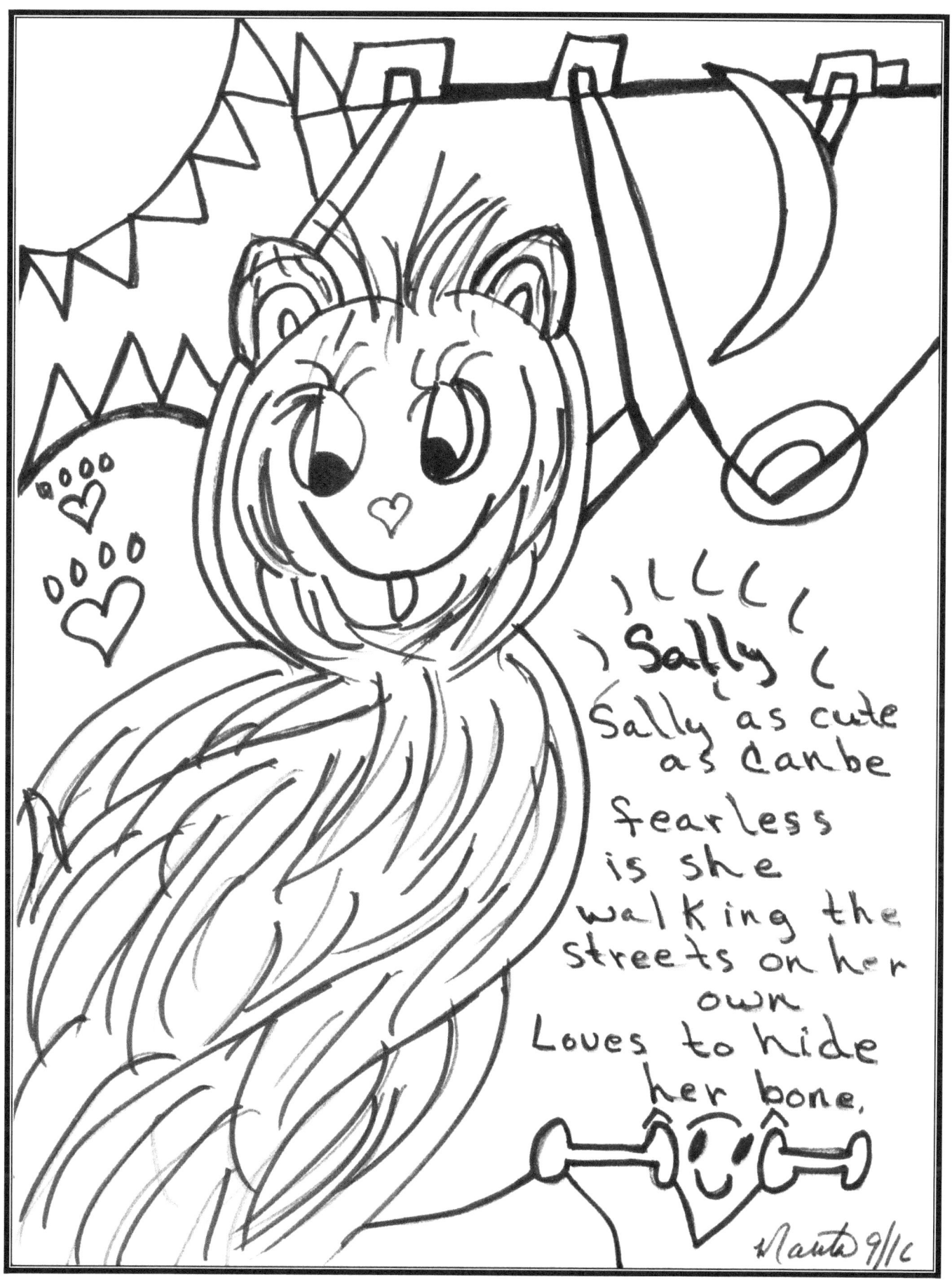

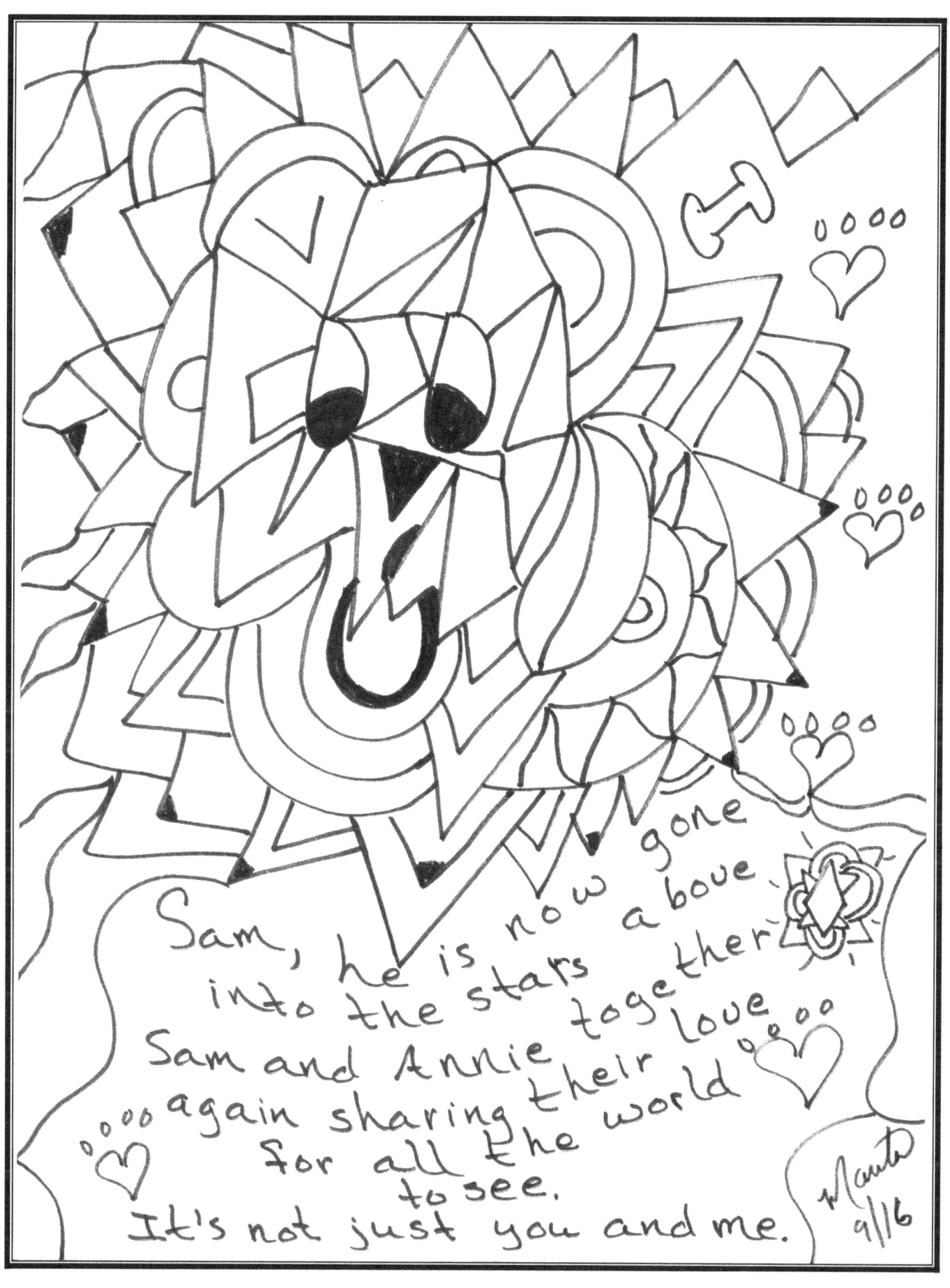

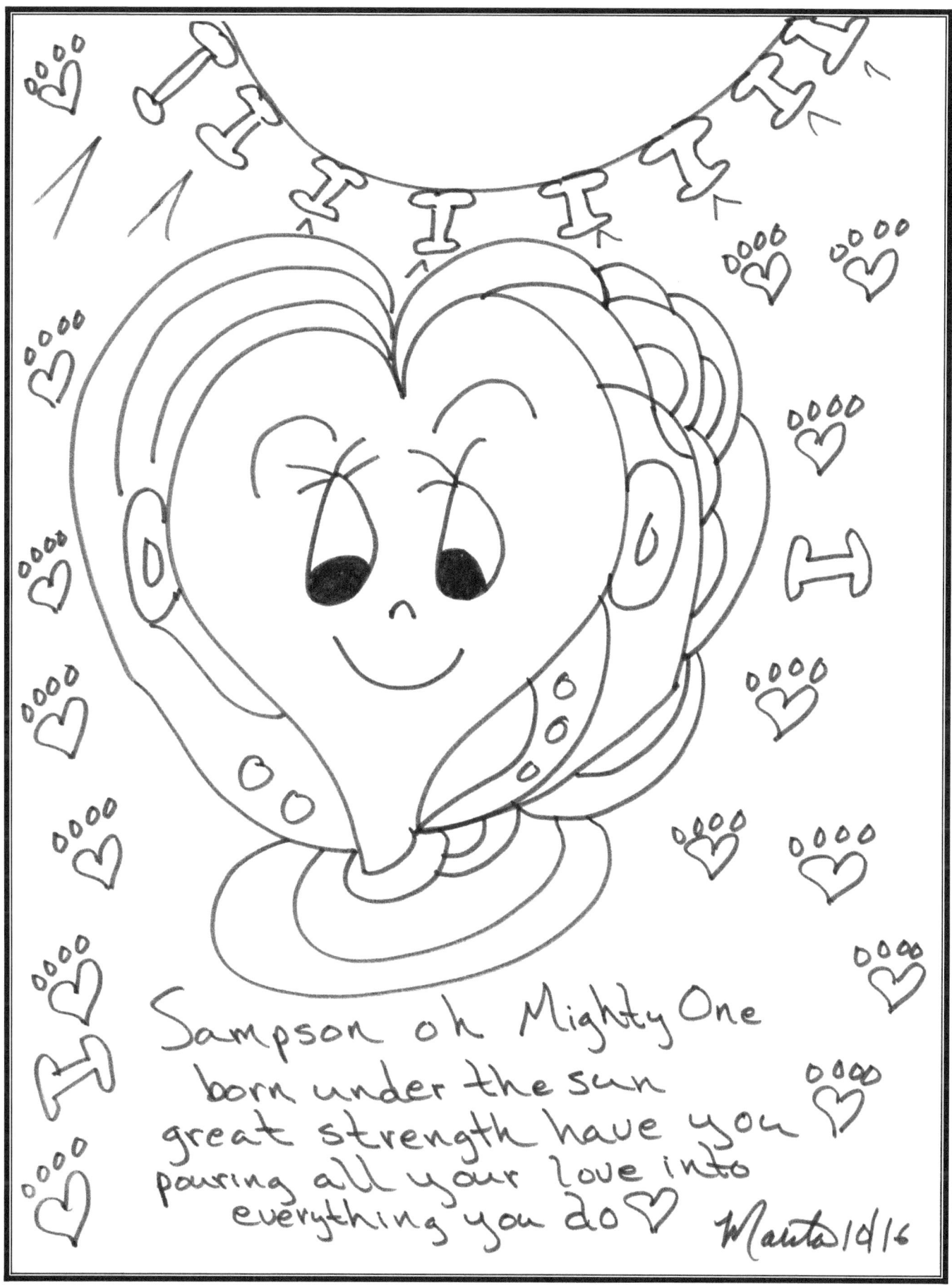

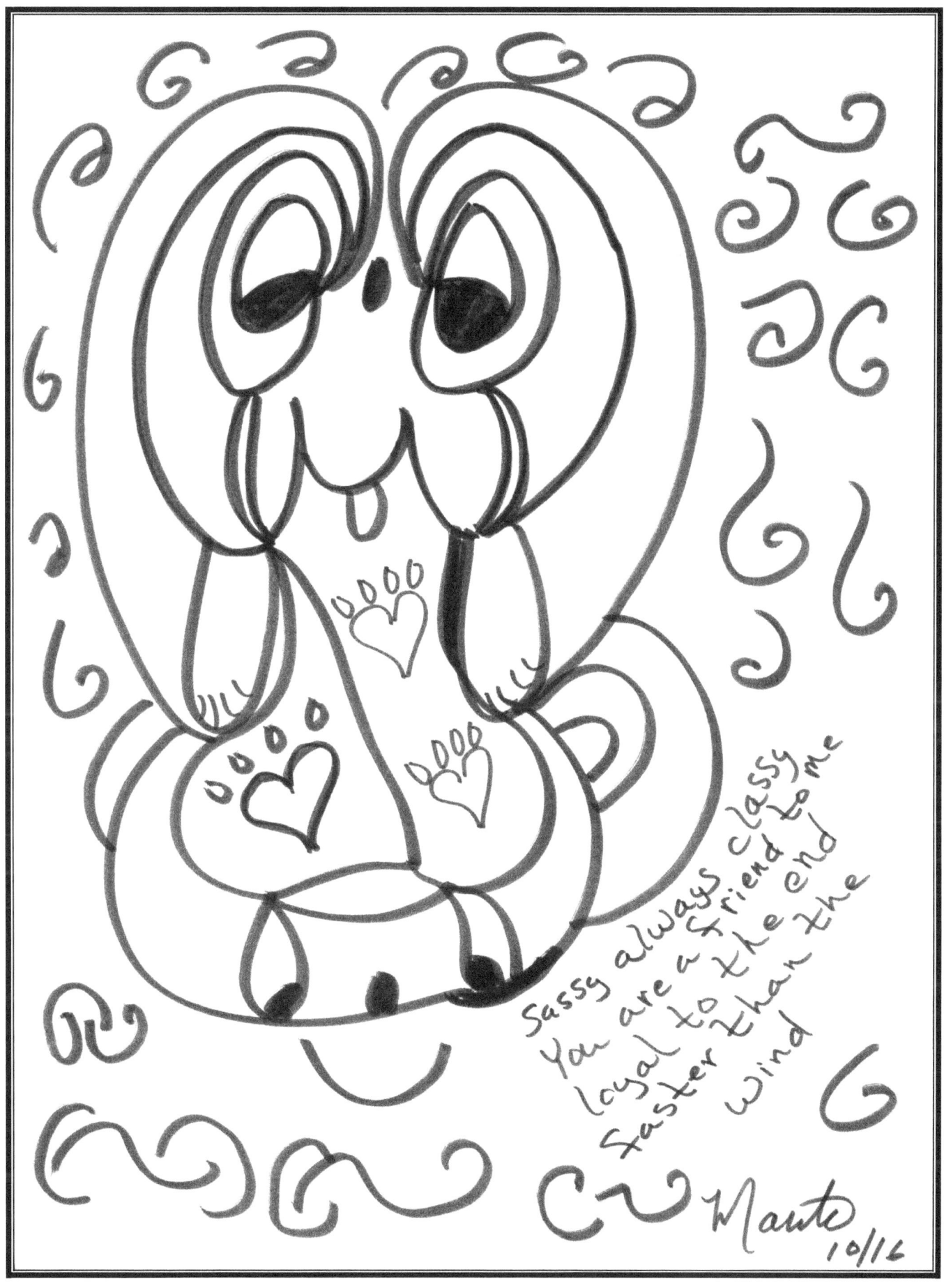

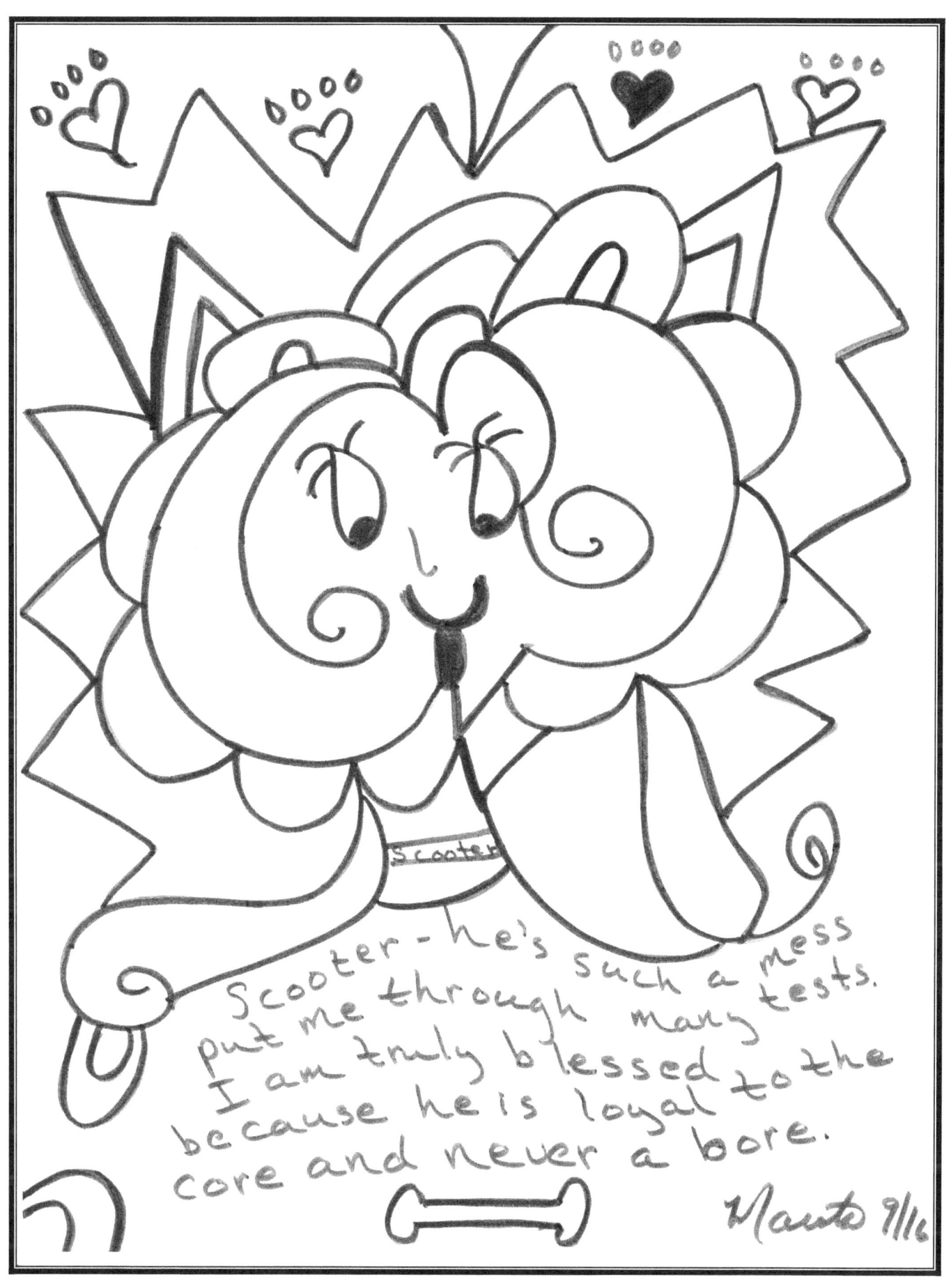

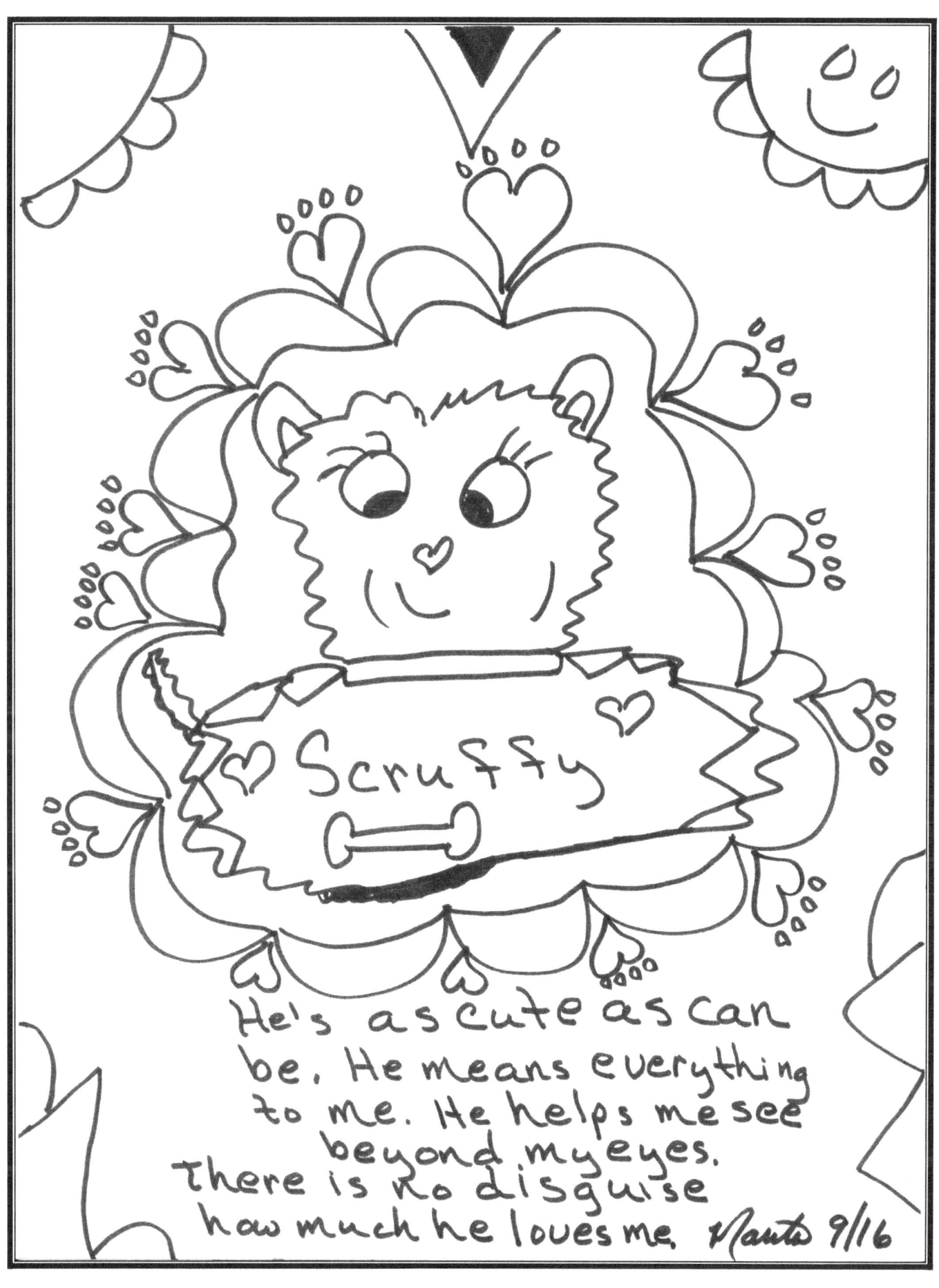

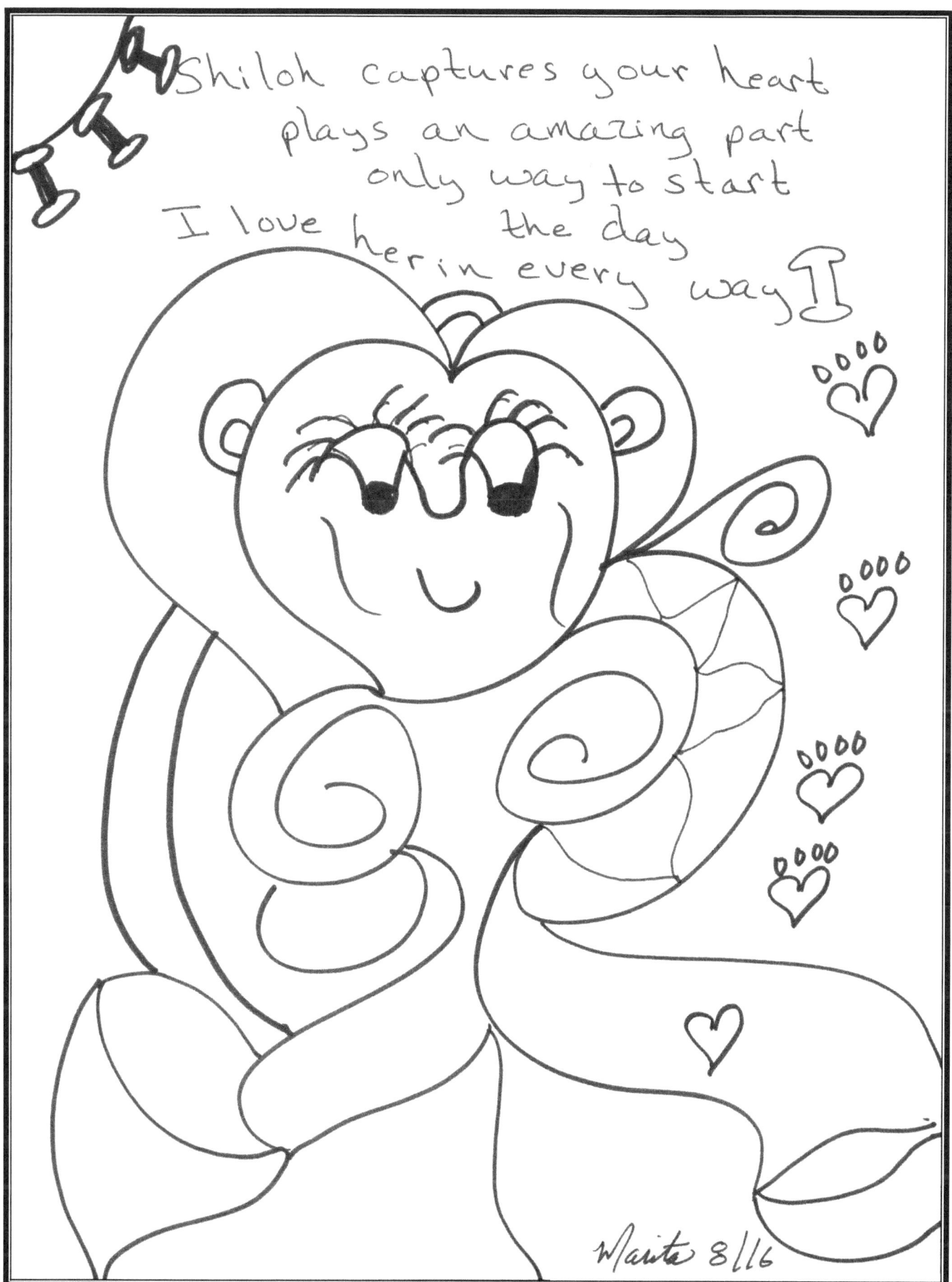

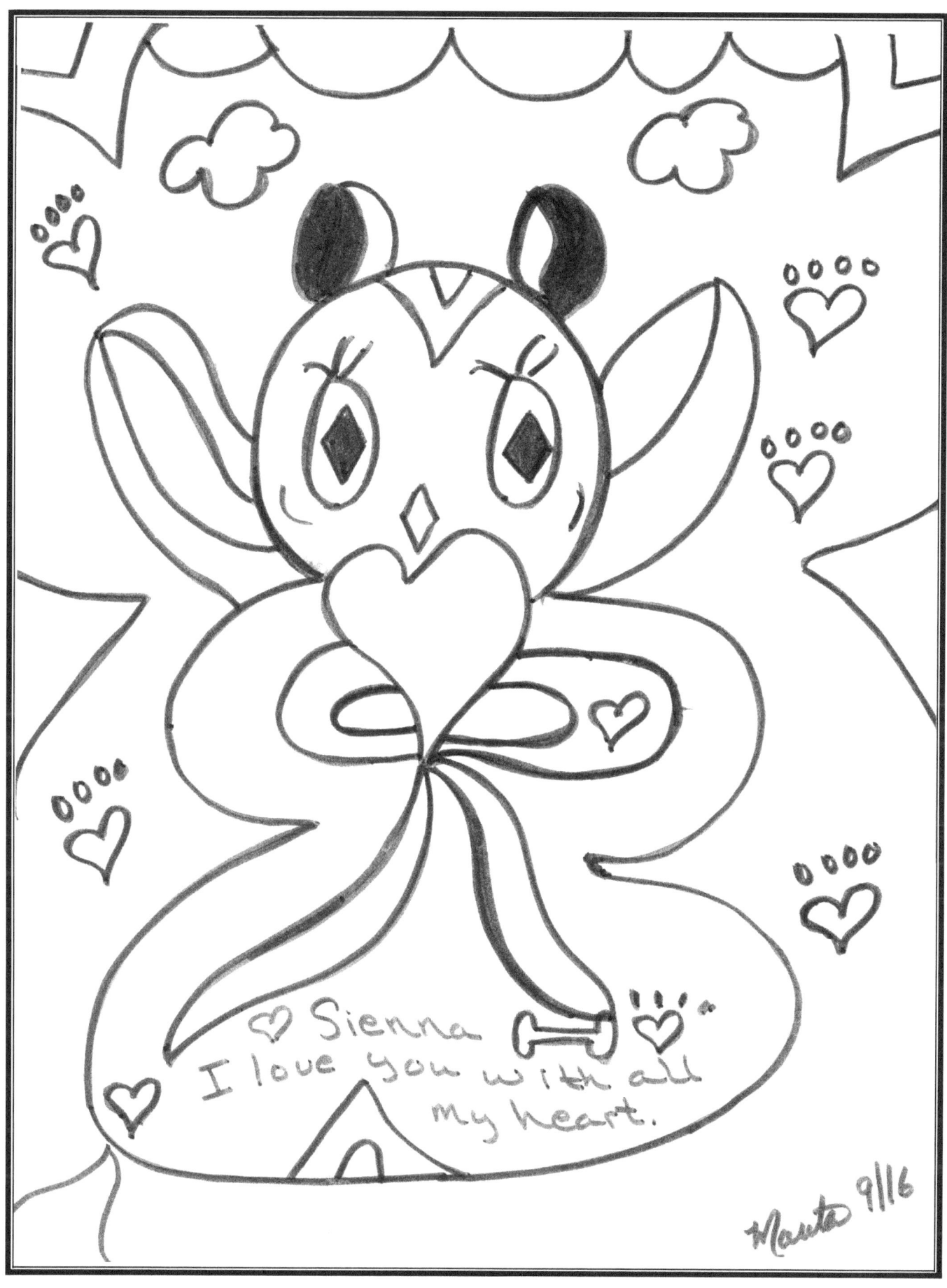

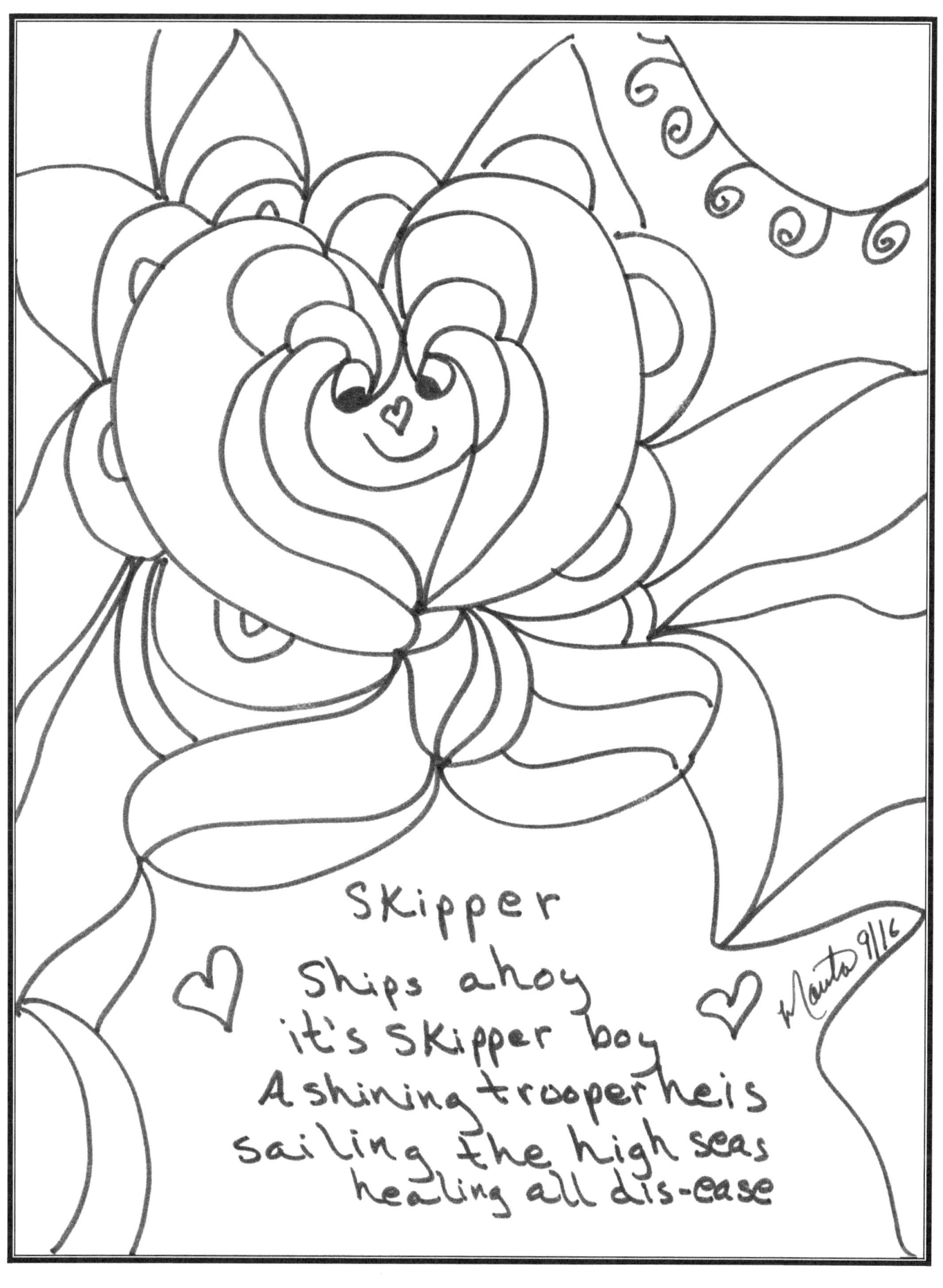

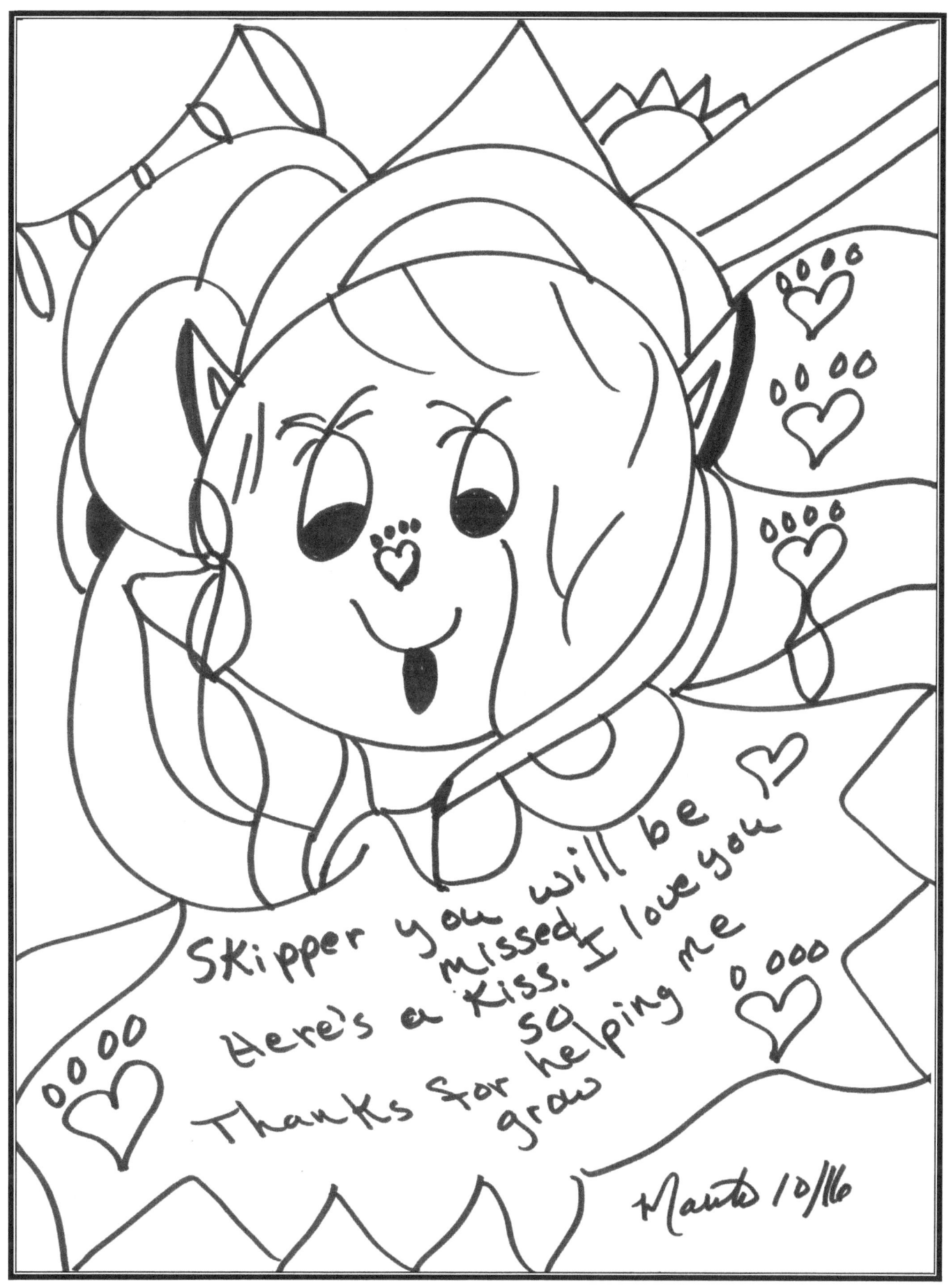

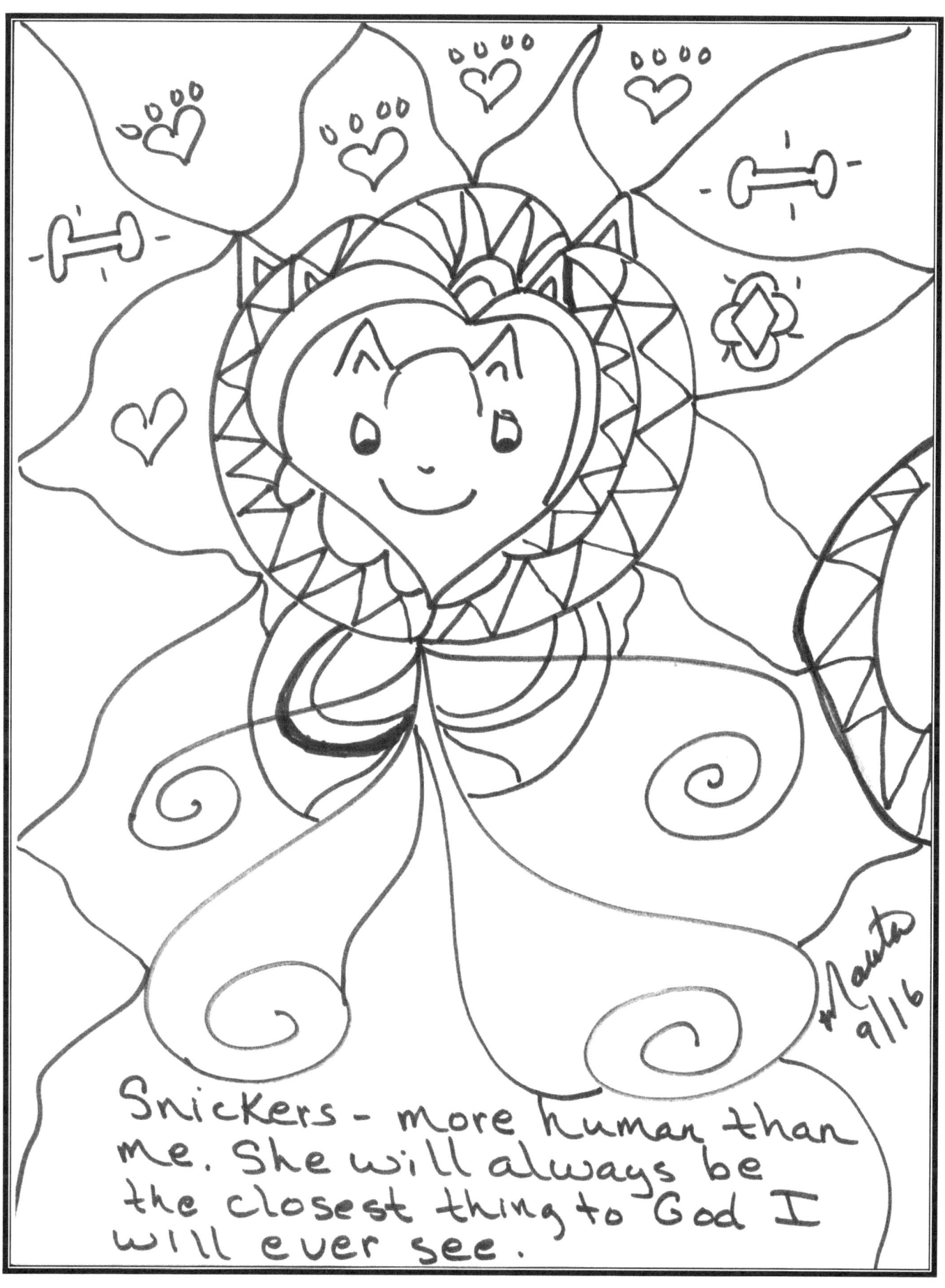

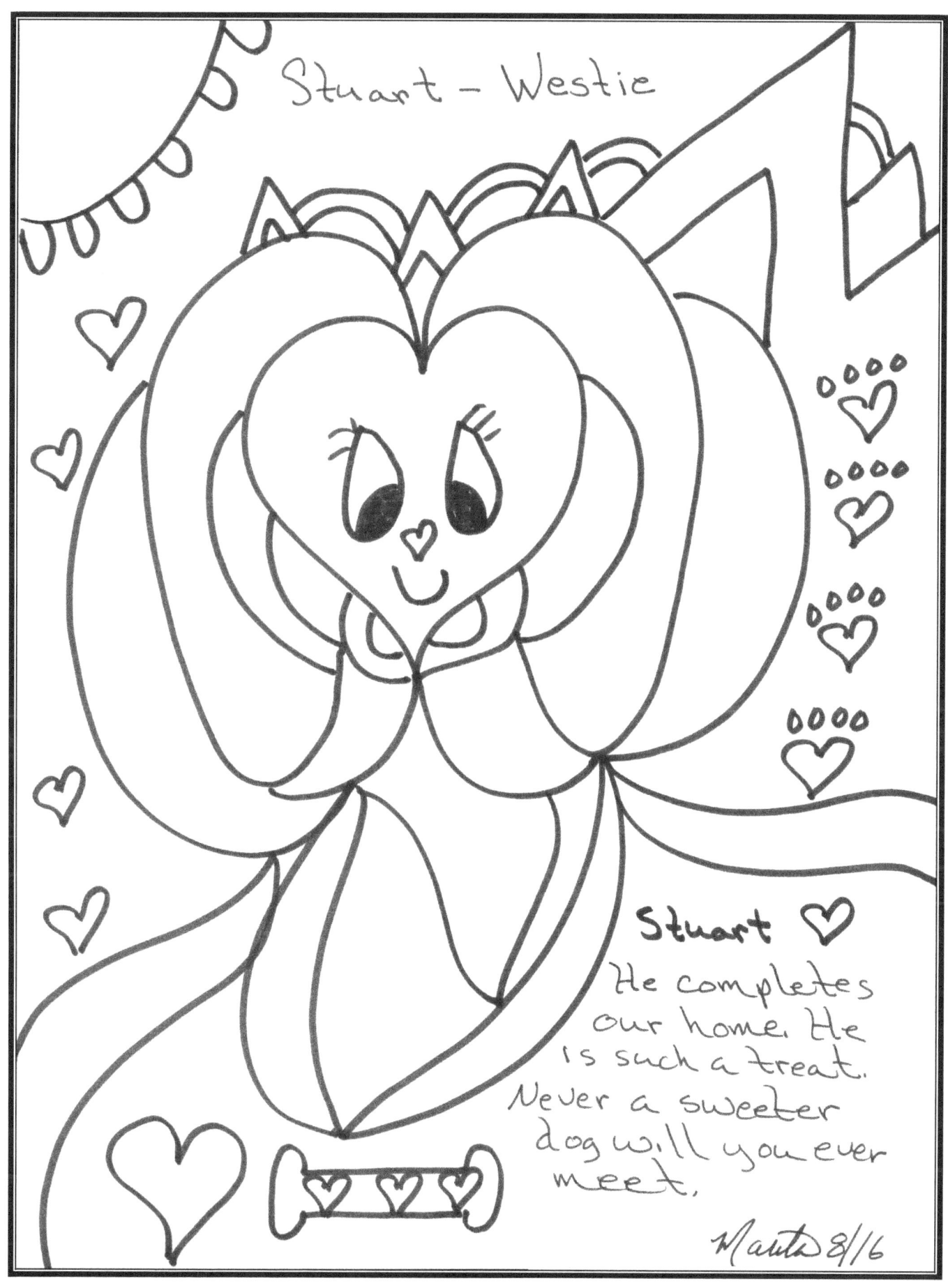

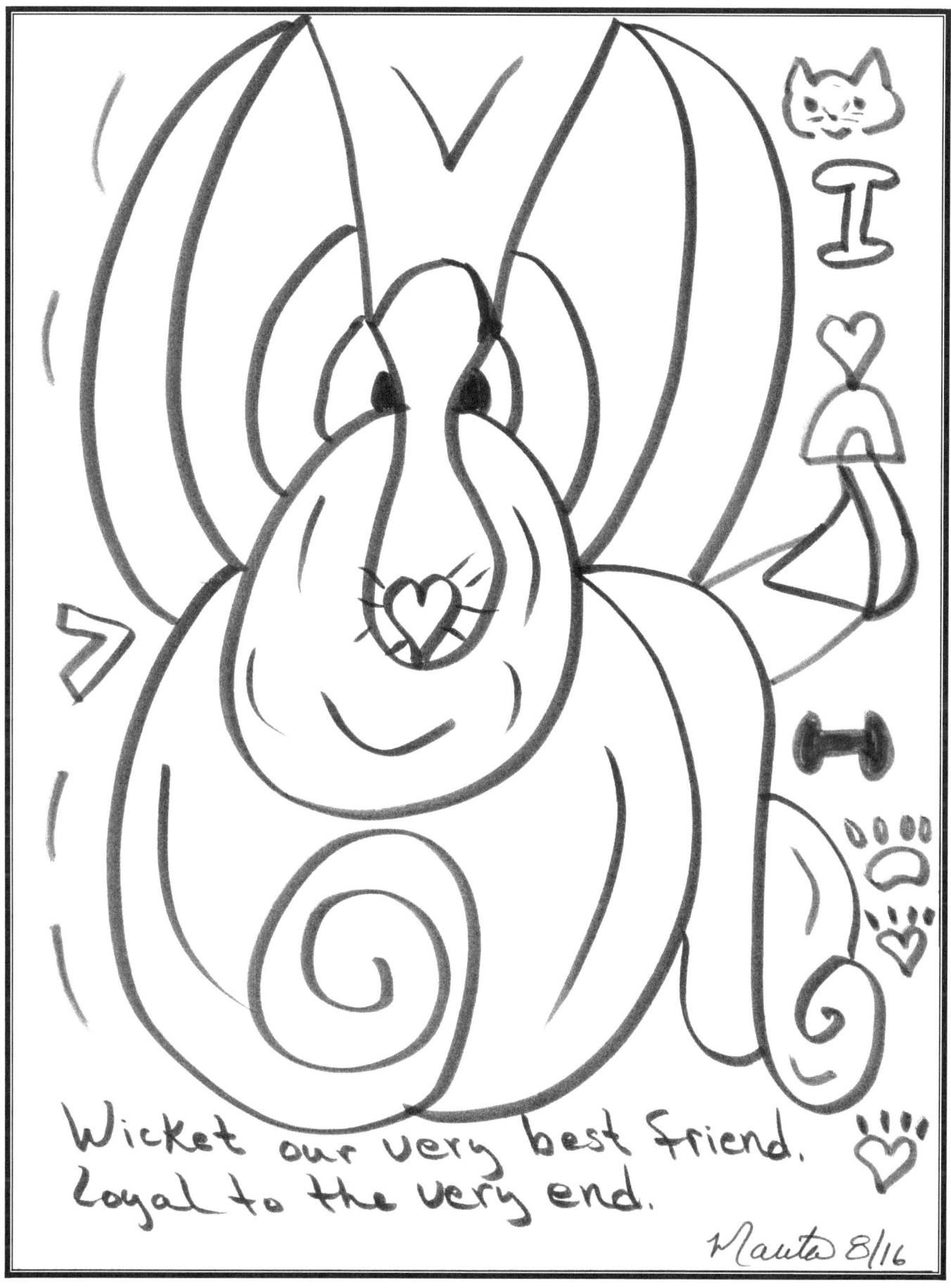

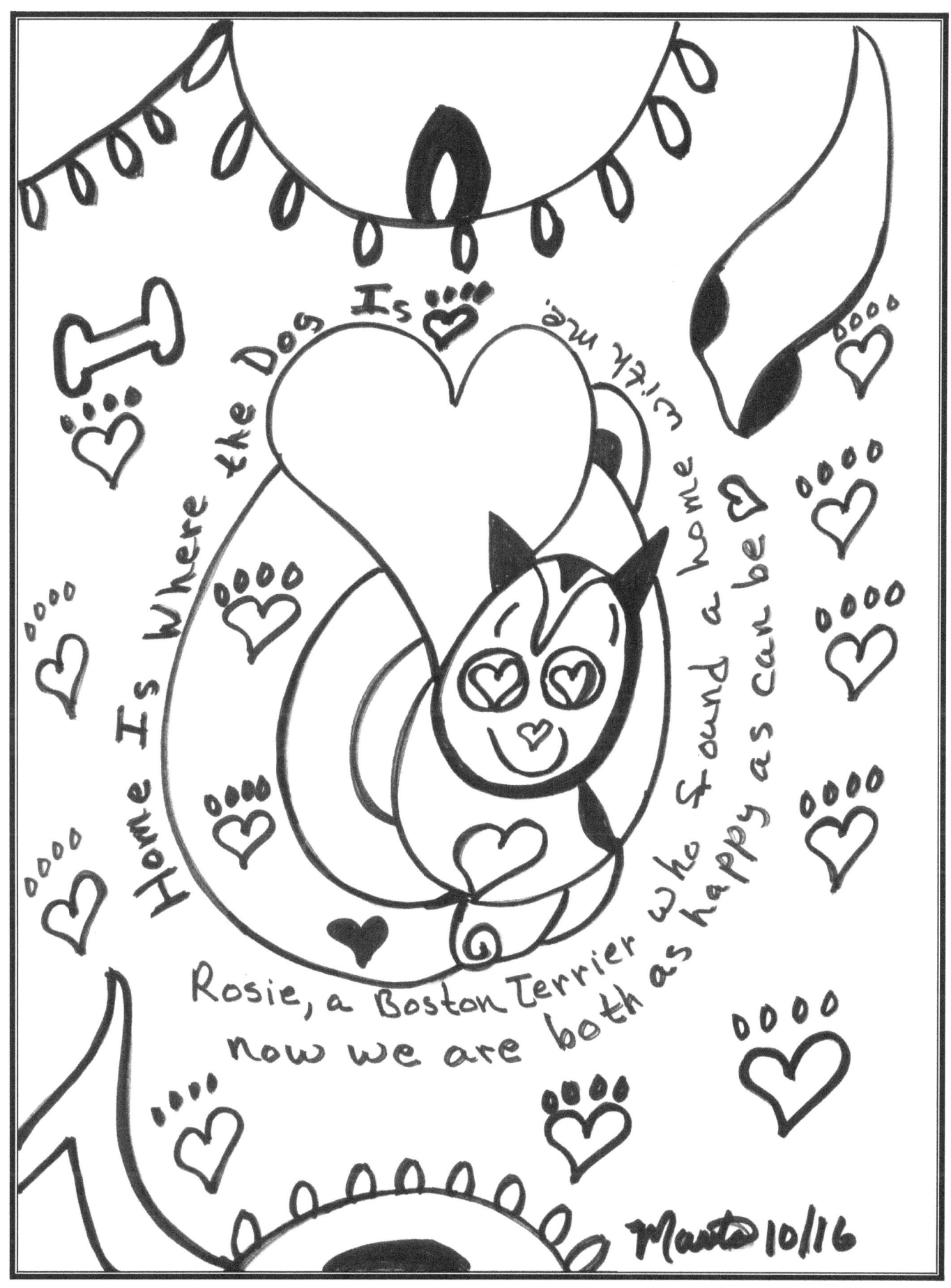

ABOUT THE AUTHOR/ARTIST

Marita's journey began in Knoxville, Tennessee, utilizing her art and poetry as an avenue to find forgiveness allowing personal growth and self-awareness to blossom.

In 2009, Marita loaded all of her personal possessions into her Honda Civic and headed for Sedona, Arizona, trusting her inner guidance to follow her creative path while being of service to others teaching forgiveness through art.

She has created countless energy portraits for people from around the world, authored numerous books which include her artwork and has been a guest speaker in cities across the country.

She was commissioned to do an article with artwork for Unity magazine celebrating mothers in the May/June 2015 issue.

She conducts art workshops across the country and is available for speaking engagements to share her story.

For more information regarding art workshops, individual sessions, or speaking engagements please contact Marita Gale at maritagale@gmail.com or wisdomandartfromtheheart.com.

www.ingramcontent.com/pod-product-compliance
Lightning Source LLC
Chambersburg PA
CBHW080702190526
45169CB00006B/2207